The Art of
Gouache

Acknowledgements

With special thanks to the following people whose photographs have been the inspiration for many of my paintings and whose generosity of spirit is an inspiration to all: Mike Wild, *Morning Milk* (page 31); John Wood, *River Darwen at Hoghton Bottoms* (pages 36–37); and Sue Leeming, *Barry* (page 126) and *Kiera* (page 130).

I also want to thank my wife Mary for putting up with me during the creation of this long-overdue book, all the skilled people at Search Press whose talents have contributed to make the book what I hope will be a huge bestseller, and my editor Lyndsey, whose patience and encouragement have made my job so much easier.

Dedication

To our great Creator who has made all things possible,
for us to marvel at, wonder and enjoy.

The Art of
Gouache

AN INSPIRING AND PRACTICAL GUIDE TO PAINTING WITH THIS EXCITING MEDIUM

Jeremy Ford

SEARCH PRESS

First published in 2019

Search Press Limited
Wellwood, North Farm Road,
Tunbridge Wells, Kent TN2 3DR

Reprinted 2019, 2020 (twice), 2021

Text copyright © Jeremy Ford 2019

Photographs by Roddy Paine Photographic
Studios and Paul Bricknell at Search
Press Studios, except for photographs
on pages 126 and 130 by Sue Leeming.
Photographs on pages 54, 81, 124 and 132
are the author's own.

Photographs and design copyright
© Search Press Limited 2019

ISBN: 978-1-78221-454-0

The Publishers and author can accept no
responsibility for any consequences arising
from the information, advice or instructions
given in this publication.

Suppliers

If you have difficulty in obtaining any of the
materials and equipment mentioned in this
book, please visit the Search Press website
for details of suppliers:
www.searchpress.com

Publishers' note

All the step-by-step photographs in this
book feature the author, Jeremy Ford.
No models have been used.

Page 1:
Rosebay Willowherb
Pages 2–3:
Last Light, East Hardwick
Opposite:
The Turning

Contents

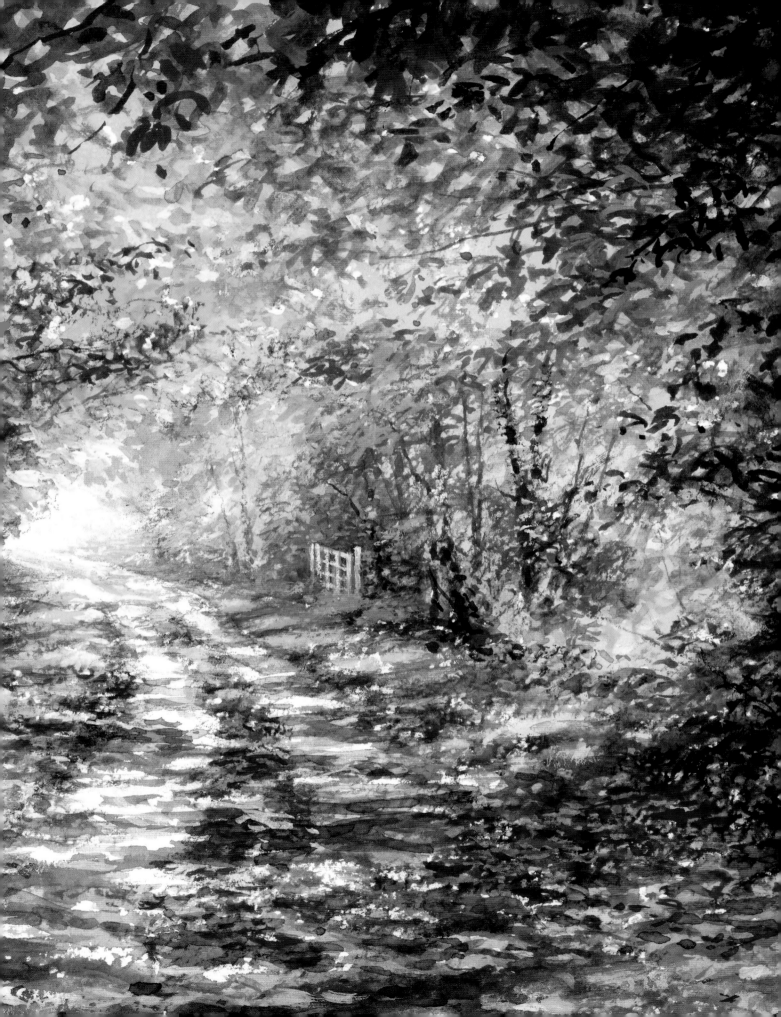

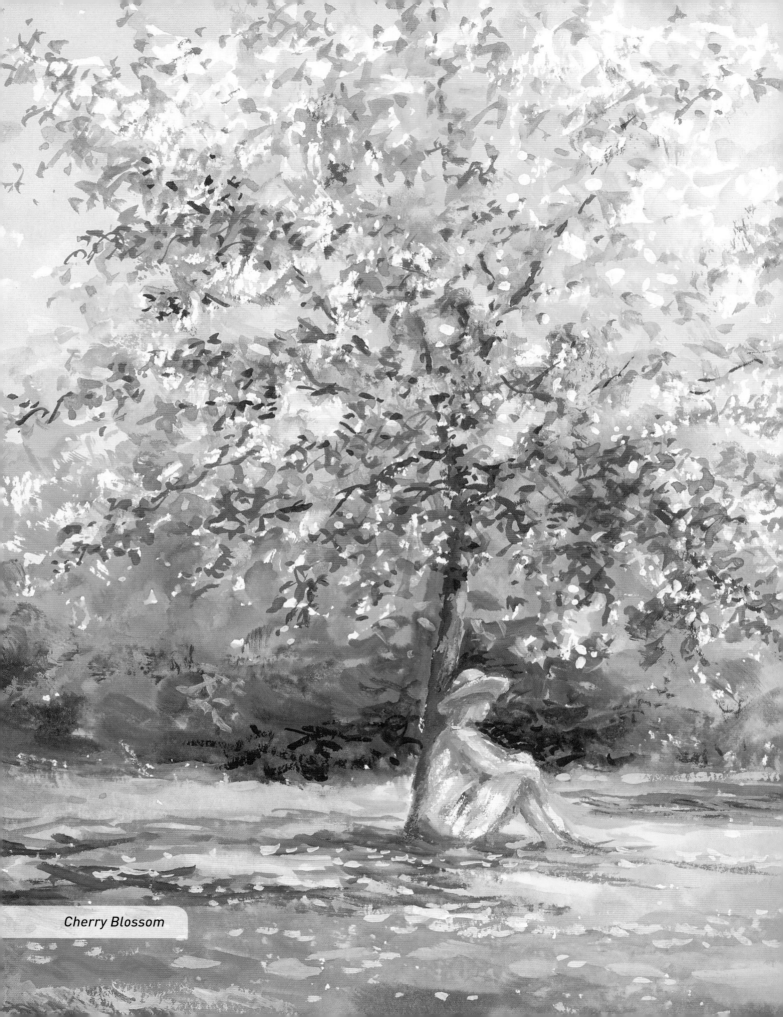

Cherry Blossom

Introduction

When I was an art student many years ago, gouache was the main paint medium used at both art colleges I attended. Its wonderful, all-round versatility made it an obvious choice for budding artists and designers.

After I qualified, I worked as a freelance illustrator and used gouache for the majority of my work because of its ease of use, familiarity and simplicity. I had to create very different styles of work from one commission to the next – from photorealism through to impressionism, watercolour style to poster style – and, in my mind, there is no better medium to achieve this diversity than gouache.

Nowadays, gouache has become almost forgotten in the sea of other paint media available to artists. Few people who paint are aware of the tremendous possibilities it can give and the adaptable nature of this neglected medium. Some watercolourists restrict its use to occasional highlights and corrections with white gouache, due to its superior covering strength compared with Chinese White watercolour.

I think gouache is the ideal paint not only for beginners, but also for more experienced artists to express their art in the widest of styles, subjects and contexts.

Gouache is well overdue a renaissance and I recommend it to you in the hope that we can all enjoy the benefits of its limitless creative possibilities.

What is gouache?

The word 'gouache' is French, from the Italian, 'Guazzo'.

Sometimes known as 'body colour', gouache is an opaque water-soluble pigment dispersed with calcium carbonate (chalk) in gum, usually gum arabic.

A form of gouache or body colour has been used for centuries to enhance paintings and increase the opacity of watercolours. It is widely used by designers, commercial artists and illustrators. To the fine artist or painter, permanence is of prime importance. Over the years, gouache for artists has improved greatly, but be aware that some colours, as with other paint media, will be less lightfast than others so it's wise to check the manufacturer's permanence ratings.

Poster paint is a cheaper form of body colour and not recommended for serious work because it is of inferior quality, often used in schools and is not necessarily meant to be permanent. I often use the term 'poster style' to describe the simple graphic block-colour designs that were done on posters years ago to great effect. Gouache is ideal for painting flat and even areas of colour.

Famous painters

Perhaps because of its association with commercial art, gouache has traditionally not been taken quite as seriously by many artists as other mediums, although it has been widely used by a good number including Toulouse-Lautrec, Valentin Serov, Matisse, Chagall and Picasso, among others.

Autumn Glory

The advantage of gouache over other paints

The term 'body' refers to the strength or solidity of the paint, and where watercolour is regarded as a transparent medium, gouache is opaque, giving a finished painting a matt look if the paint has been applied fairly liberally. Light colours can be painted over dark colours which is not usually or easily done with watercolour. Painting with watercolour paint alone can result in the white of the paper getting completely smothered and the resulting watercolour painting can easily become muddy and overworked. This is where gouache has the advantage, as we can paint the opaque gouache over any muddy or dreary watercolour once it has dried.

A pale colour in watercolour tends to be a watery mixture covering the paper in a thin layer, allowing the brightness of the paper to shine through the transparent paint. A pale colour in gouache can be a thin watery layer, but is more usually made with the addition of white, which tends to be frowned upon in watercolour circles.

The amount of pigment within the paint can vary from one brand to another, and the strength of pigment from colour to colour but generally there is a greater concentration of pigment in gouache than in watercolour.

Gouache is not to be confused with acrylic paint, which is also water soluble until it dries permanently. Unlike acrylic paint, gouache can be reworked when dry with a wet or damp brush. This advantage makes for great subtlety when needed, particularly for illustrative work. Care should be taken, however, not to apply gouache on its own too thickly as impasto (very thick layers), as it can crack when dry and fall off the painting surface.

The opaque nature of gouache makes it ideal for painting on a coloured surface to great effect and its brightness and covering strength can create good contrasts.

When mixed with white, gouache will dry darker than it looks while wet, and when darker colours are mixed it will generally dry lighter, so matching colours after the paint is dry can be difficult.

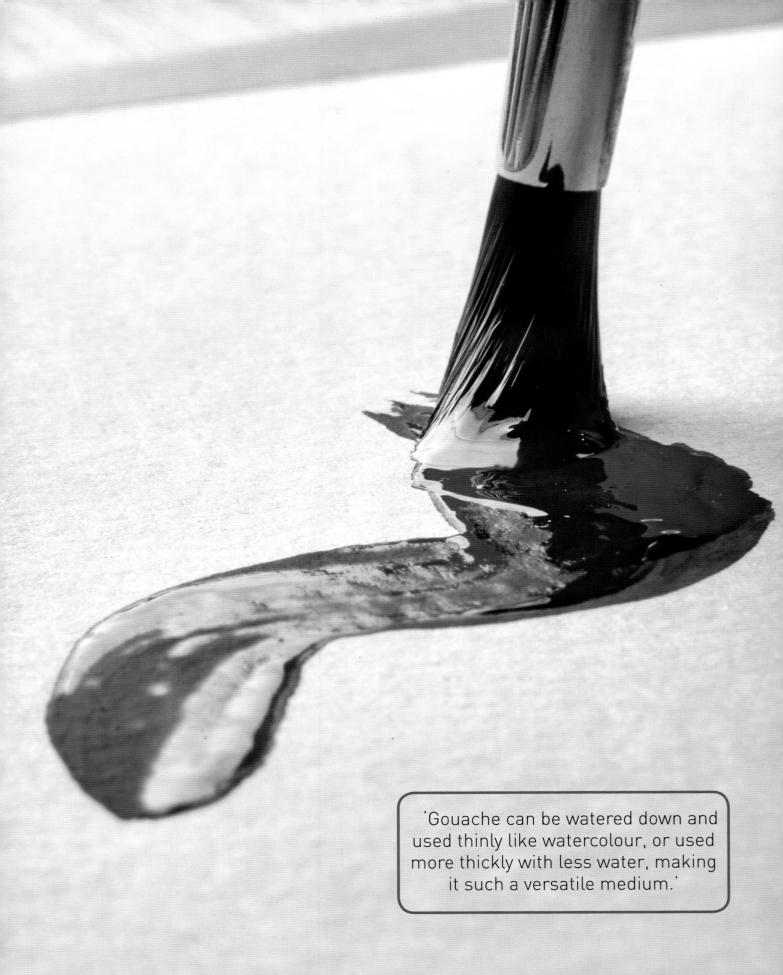

'Gouache can be watered down and used thinly like watercolour, or used more thickly with less water, making it such a versatile medium.'

Materials

If you ask a dozen or more different artists what are the best materials to use, you'll probably get a dozen or more different answers! I have selected the materials I think are ideal for producing the best possible work and I hope that you will see the evidence of my reasoning within these pages.

Paint

Gouache is usually sold in tubes of paint but is also available in pans in a gouache paint box. I recommend tubes of gouache colours which are easily made into good quantities of strong paint in the palette. You will use more white than any other colour, so maybe buy a couple of tubes.

When buying gouache paint, buy the best you can afford and avoid cheaper, student brands which can lack strength and body. I have only used a few brands and there will be many others I haven't tried which may be quite similar, or quite different.

Key tip

If you already have watercolour equipment, you can use this for gouache painting.

Brushes

I suggest using round watercolour brushes for gouache. A good range of brushes will include a size 10 (minimum), then sizes 8, 6, 4 or 3 and 1 or 0. Depending on the size you want to paint, you may need larger brushes for covering large areas. I usually use synthetic brushes as opposed to sable brushes, as I can create a variety of effects more easily. Sable brushes tend to be softer and better used for very wet painting. I'd also add a hake or a flat brush for washes and wetting the paper where necessary.

Palettes

I have a variety of palettes I use for gouache. I need one that has large wells in for mixing plenty of each colour, sometimes with a lot of water and sometimes thicker. The wells need to be spacious enough for the amount of paint I need and there are a variety of appropriate palettes available to buy.

A good example of such a palette is the School of Colour melamine palette which is shaped in the form of a colour wheel and helps assist colour mixing as the colours are arranged in a circular fashion so you can see how they relate to each other.

I also have a ceramic palette which is sturdy and easy to clean and a plastic palette which has plenty of mixing space. Some smaller plastic palettes can be too light and may move around on your work surface, and a lightweight one may need securing with tape so it doesn't tip over or spill.

Key tip

Use a mixing well that allows you to mix plenty of colour to come back to, as it can be hard to mix the exact colour another time.

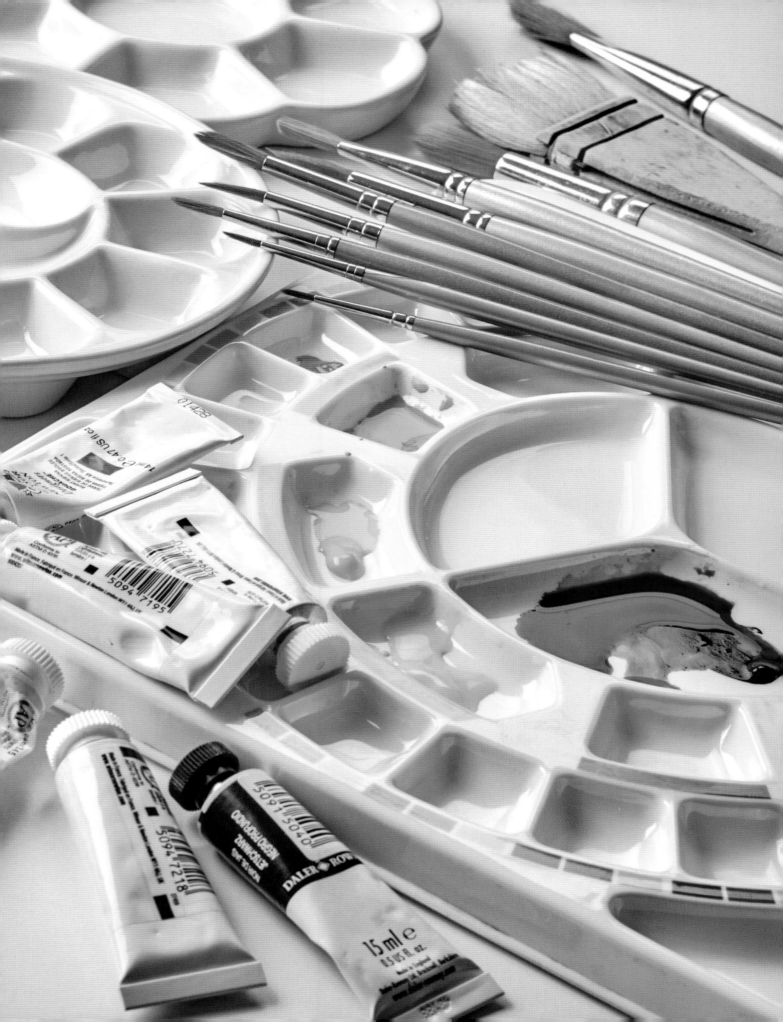

Paper

I would recommend using paper
that is 300gsm (140lb) or heavier. I use
hot-pressed watercolour paper for fine, detailed
work, as its smoothness is ideal for greater control.

More often I use Not surface or rough watercolour papers
for most work, particularly favouring heavier weight papers. These
papers allow me to create textural effects more easily than smooth
papers, as the surface of the rougher paper can be used to great effect. The
heavier or thicker the watercolour paper, the less it will cockle or buckle or
distort when wet and a less heavy watercolour paper may need stretching onto
a wooden drawing board with brown gum strip. Paper to be stretched should be
soaked for at least five minutes (it can't be over-soaked) and when wet it expands.
After soaking, it is quickly removed, then placed and kept flat on the drawing board
while the gum strip is wetted and applied to each edge, opposites first. As the paper
dries, it contracts and the gum strip holds it firmly in place leaving a flat surface
for painting. The paper must be kept on the board until the painting is finished and
dried, and then it can be removed from the board with a sharp knife.

There are other paper-stretching devices also available, and an internet search
will provide a number of alternatives to the gum strip method.

I occasionally use a Line and Wash Board which is a smooth-ish paper
bonded onto card which stays flat. Some people like to work on other
surfaces, but as long as it's appropriate (and, if not, has been primed
so the gouache adheres) I'd just stick with using paper, preferably
watercolour paper. I wouldn't use it on a primed canvas or
anything that is likely to stretch or contract as gouache
can crack and possibly fall off if it is applied very
thickly onto such a surface.

Additional items

1 Kitchen paper or tissue is really good for wiping brushes and removing the wetness from a brush for drier brushwork.

2 A water jar is essential for cleaning your brushes.

3 A water dropper or pipette is useful for adding water to thin the paint.

4 A water spray-bottle helps to keep your gouache from drying out on the palette.

5 A good size plastic or ceramic palette with plenty of space for different mixes.

6 A hairdryer can speed up the drying time.

7 If you're not working on a watercolour block, **a drawing board** will enable you to stick your paper down on it with masking tape **(8).**

9 I like to use a **B or 2B pencil** which is ideal for drawing, along with an eraser **(10).**

11 Plastic food wrap can be used for certain interesting effects. It can also be used to cover a palette to keep paints workable and help prevent them drying out inbetween painting sessions.

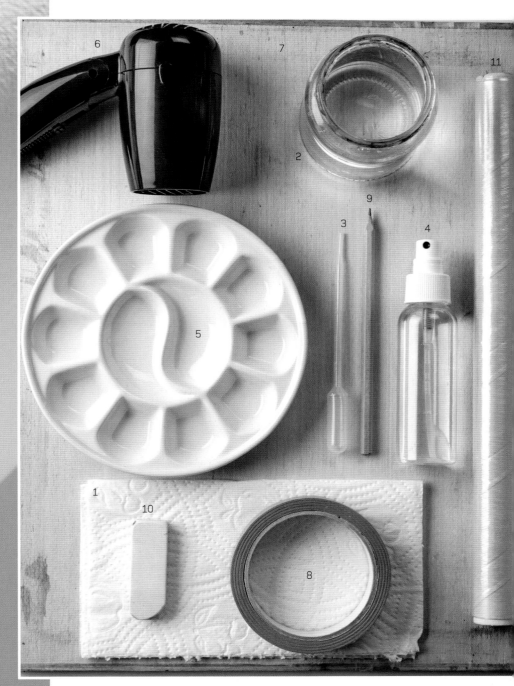

Getting started

If you are familiar with other paint media you may already use certain techniques and/or brushes that can help achieve particular effects. If I am not sure how to do something I will experiment on a spare piece of paper first. I also ask myself some questions: What effect do I want to achieve? Is there a paper surface that would help that? Is there a consistency of paint or a type of brush that would make it easier? Be prepared to experiment!

Regardless of which style of gouache you intend to paint in, you will need to prepare your paint. You can achieve different consistencies with gouache paint (see opposite). I find it helpful to describe the different consistencies as watery, milky, like single cream and like double cream.

Key tip

Use two water jars: one to rinse the brush and one to paint with.

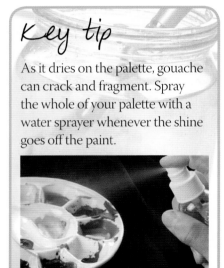

Key tip

As it dries on the palette, gouache can crack and fragment. Spray the whole of your palette with a water sprayer whenever the shine goes off the paint.

Preparing your paint

1 Squeeze the neat paint out of the tube into a mixing well.

2 Squeeze two to three drops of water from the water jar into a different well, using a water dropper or pipette.

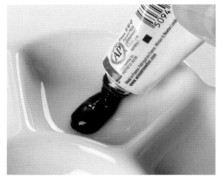

3 Using a dry round brush, dip into the paint and pick up enough paint to cover the end of the brush.

4 Add this to the water to make a glutinous consistency like double cream.

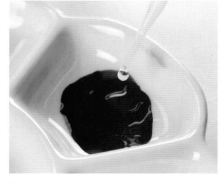

5 To make a thinner consistency, add more water with the dropper.

Paint consistency

Watery consistency

Milky consistency

Single cream consistency

Double cream consistency

Washes

A wash is a layer of colour, usually applied fluidly with a brush. I often like to use Bockingford 535gsm (250lb) Not surface watercolour paper. To stop the paper from moving and to hold it tight, tape your paper to a board using strong masking tape or framing tape. Prepare your paint to a creamy consistency in the mixing well. It is important to make sure that the colours are thoroughly mixed so that you achieve a smooth and even finish.

Flat wash

A flat wash is a single layer of colour applied as a wash which is uniformly even. You would use a flat wash to create a smooth effect, for example, for painting an even sky. Here I am using a size 10 round brush. For larger areas, use a larger brush.

 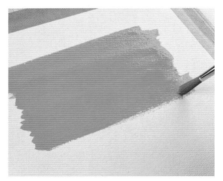 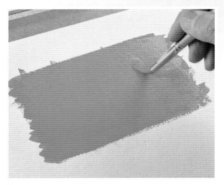

1 With paint on the end of your brush, paint onto dry paper. As I am right-handed, I tend to work from left to right. Reload the brush as the paint runs out.

2 You can use any brushstrokes and make any shapes, but ensure that all the paper is covered and there is no texture or visible brushstrokes. Paint in as smooth a manner as possible.

3 If, when dry, you can see some variation in the texture, you can paint over the top. I use some vertical strokes to smooth out the brushstrokes that show through.

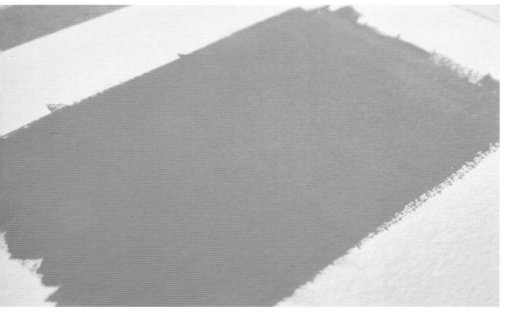

4 Some gouache paint is thicker than others, so you might need to try a couple of times to get it right. A thicker consistency will work better.

Gradated wash

A gradated wash, sometimes called a graduated wash, graded wash or a gradual wash varies in colour, strength or tone. For example, the first application of paint as a strip of colour may subsequently be weakened or strengthened, lightened or darkened as you progress, creating variation from one area to another.

You could use a gradated wash to portray still water, sky, mist or a sunset, among other things. You can use the same principle for going from one colour to another colour, as shown overleaf. Gradated washes are an example of blending, see pages 40–41 for more detail.

1 Using the same mix of colour and creamy consistency described opposite, paint from one side to the other.

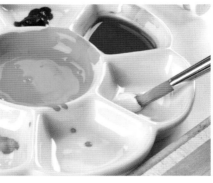

2 When you run out of paint on your brush, dip it into the white paint. It isn't necessary to rinse the brush first if you are only using that white paint for this, but if you are using white elsewhere with other colours, rinse your brush first so it doesn't become adulterated with that colour.

3 Apply the white, slightly overlapping with the orange.

4 Add a touch of water and more white, repeating the process so it becomes paler lower down.

5 Work back up the paper if necessary, removing any visible lines.

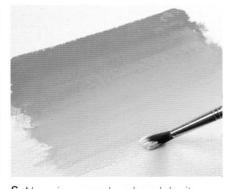

6 Now rinse your brush and dry it on kitchen paper before dipping it into the white. Paint horizontal strips backwards and forwards, then work back up the paper and paint over what is already there until smooth. The brush needs to be damp, rather than too wet.

7 Rinse your brush thoroughly then dip into the white again. Add white to make the colour paler. If the streaks are obvious, paint over them again without using too much water.

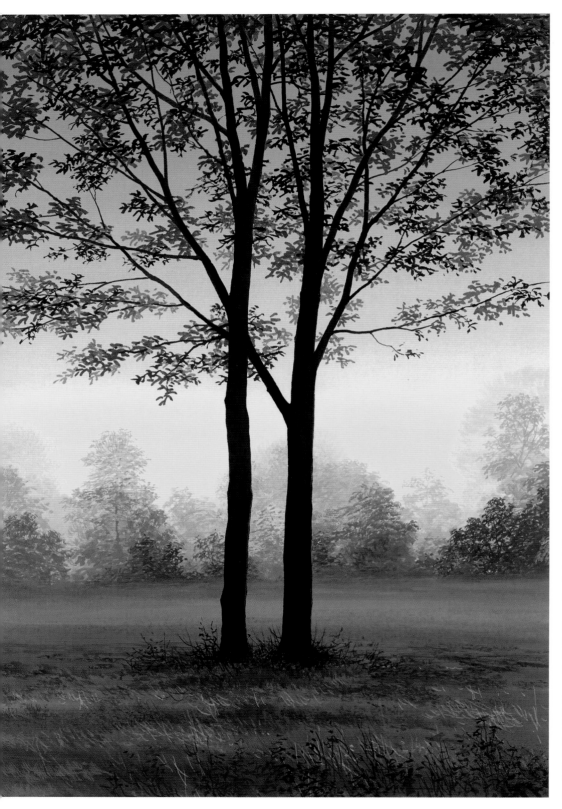

Morning

The blue was a mixture of white with Prussian blue and ultramarine which makes a kind of cobalt blue. Where the blue and yellow meet needs to be very light, otherwise green can become apparent.

In the background the blue was added to a little black and white to create distant trees, blacker greys for nearer trees and solid black for foreground trees and foliage.

The mist was created before the main trees as a gradated wash with white and black, softly blending to avoid distinct lines.

The sky colours were blended, blue into yellow, and the mist was blended into the darks below and above. Apart from those areas, the rest of the painting is largely done with fairly flat areas of colour and tone.

These two finished pieces demonstrate a gradated wash from blue to yellow, and (opposite) from red to orange.

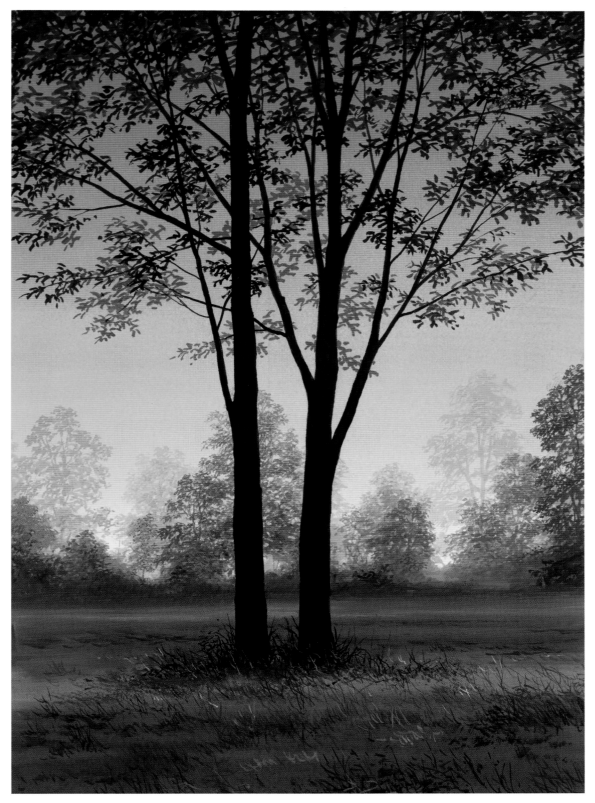

Evening

For the top of the sky, cadmium red (or vermilion) was mixed with a small amount of permanent rose. Cadmium yellow was added more and more lower down. This was painted in the same way as the *Morning* picture opposite, but the yellow is lighter on the horizon, so more white was added to the yellow/orange lower down.

Colour and light

My palette

I use a limited palette based around two reds, two yellows and two blues, which gives me a massive range of colour mixes. Colours can vary enormously from brand to brand and I know that many apparently different colours can be similar to others of another name. I tested all the colours you can see and then settled on selecting what I consider to be the minimum that will give me the maximum number of mixes.

If you have a limited number of colours in your palette you become familiar with those few colours and with experience you learn what can be mixed from two of those colours in varying proportions, and three of those colours in varying proportions. The more colours you have to choose from, the more decisions you have to make, and too much choice can be bewildering. With practice, you can learn to mix any other colour just from a limited few. Whatever medium I use I generally stick to this limited palette of the same, or very similar, colours.

Lightfastness

I also like to know that the colours I use are as lightfast as possible, so I check the pigment(s) number(s) (if supplied on the label) with reliable internet sites that provide such information. As a general rule, vibrant brilliance usually means less permanence and greater permanence usually means slightly less vibrant brilliance.

My core palette

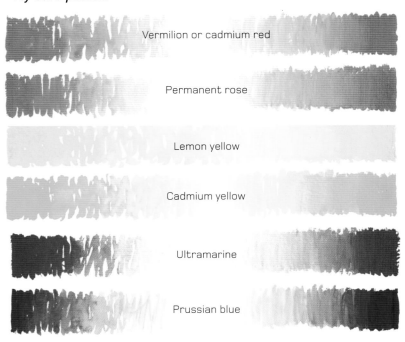

Vermilion or cadmium red

Permanent rose

Lemon yellow

Cadmium yellow

Ultramarine

Prussian blue

Useful additional colours

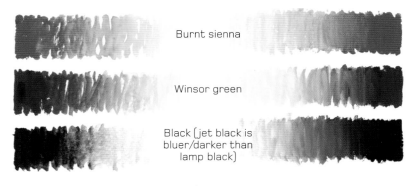

Burnt sienna

Winsor green

Black (jet black is bluer/darker than lamp black)

White (permanent white, titanium white, or zinc white)

> **Key tip**
>
> The use of black is often discouraged as it can appear flat or uninteresting on its own, but I find it can be useful when used with other colours (see colour grids on pages 28–29).

Making paint paler using gouache or water

Each colour is made paler with water (left-hand column) or with white gouache (right-hand column). It's interesting to compare colours made paler with the addition of water with colours made paler with the addition of white. You can see differences in transparency, opacity and brightness.

A note on manufacturers

Here you can see the manufacturers and colours that I use. However, there are many other makes available throughout the world that I wouldn't want to dismiss, but I've only been able to use these here and others may be just as good, better or worse. There are certain makes of colours that I prefer, such as Winsor & Newton's cadmium yellow because it is brighter than Daler-Rowney's, and I prefer Daler-Rowney's jet black to any other black, but that's just me. It's hard to say whether or not it makes a huge difference because many makes of gouache are excellent, yet some are poor quality. At the end of the day, we all have our own favourite colours and makes.

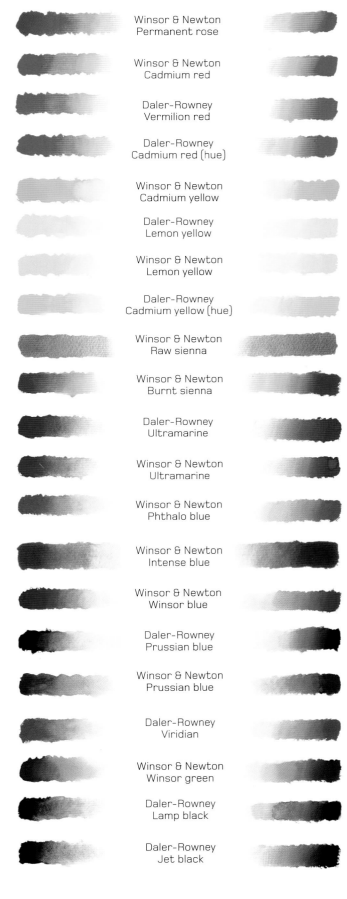

Winsor & Newton
Permanent rose

Winsor & Newton
Cadmium red

Daler-Rowney
Vermilion red

Daler-Rowney
Cadmium red (hue)

Winsor & Newton
Cadmium yellow

Daler-Rowney
Lemon yellow

Winsor & Newton
Lemon yellow

Daler-Rowney
Cadmium yellow (hue)

Winsor & Newton
Raw sienna

Winsor & Newton
Burnt sienna

Daler-Rowney
Ultramarine

Winsor & Newton
Ultramarine

Winsor & Newton
Phthalo blue

Winsor & Newton
Intense blue

Winsor & Newton
Winsor blue

Daler-Rowney
Prussian blue

Winsor & Newton
Prussian blue

Daler-Rowney
Viridian

Winsor & Newton
Winsor green

Daler-Rowney
Lamp black

Daler-Rowney
Jet black

Primary colours, secondary colours and complementary colours

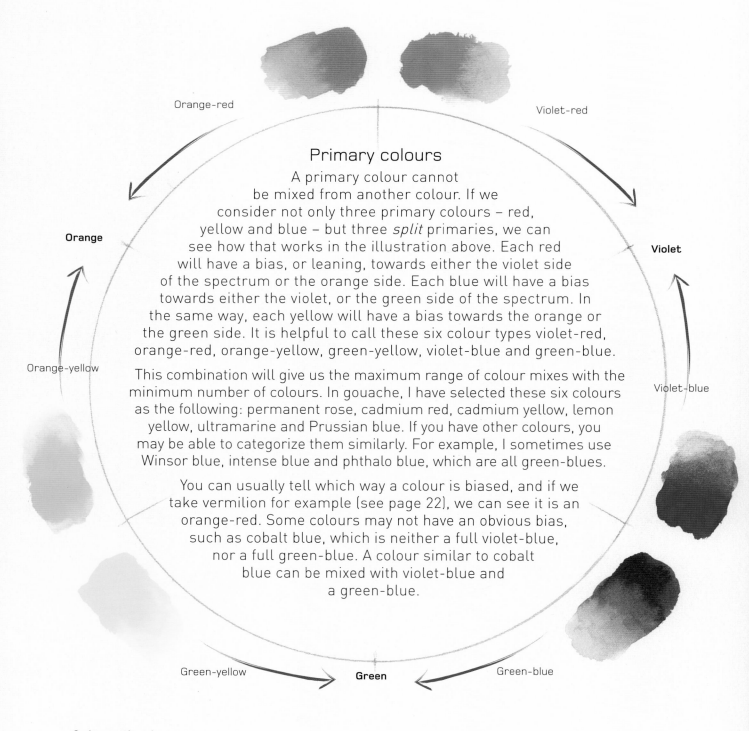

Orange-red

Violet-red

Orange

Violet

Orange-yellow

Violet-blue

Primary colours

A primary colour cannot be mixed from another colour. If we consider not only three primary colours – red, yellow and blue – but three *split* primaries, we can see how that works in the illustration above. Each red will have a bias, or leaning, towards either the violet side of the spectrum or the orange side. Each blue will have a bias towards either the violet, or the green side of the spectrum. In the same way, each yellow will have a bias towards the orange or the green side. It is helpful to call these six colour types violet-red, orange-red, orange-yellow, green-yellow, violet-blue and green-blue.

This combination will give us the maximum range of colour mixes with the minimum number of colours. In gouache, I have selected these six colours as the following: permanent rose, cadmium red, cadmium yellow, lemon yellow, ultramarine and Prussian blue. If you have other colours, you may be able to categorize them similarly. For example, I sometimes use Winsor blue, intense blue and phthalo blue, which are all green-blues.

You can usually tell which way a colour is biased, and if we take vermilion for example (see page 22), we can see it is an orange-red. Some colours may not have an obvious bias, such as cobalt blue, which is neither a full violet-blue, nor a full green-blue. A colour similar to cobalt blue can be mixed with violet-blue and a green-blue.

Green-yellow

Green

Green-blue

Colour wheel

24

Secondary colours

Mixable secondary colours are between each set of split primaries and the nearest primary will give the brightest secondary mix. For example, if we mix the orange-red with the orange-yellow, as the names suggest they will give us the brightest orange mixes. If, instead, we use the violet-red with the orange-yellow, the resulting mix will be less bright than our previous mix, and similarly, if we use the orange-red with the green-yellow to mix our orange, it will also be less bright than our original mix. A mix of the violet-red and the green-yellow would give us even duller mixes of oranges.

In the same way, the brightest greens can be mixed with the nearest blue and the nearest yellow, and the brightest violets can be mixed with the nearest red and blue.

It is important to stress that when painting with subtle mixes, we may not want to mix very bright colours, and slightly more neutralized colours may be required. In that case, it helps to understand how each of our colour types relate to each other from the split primary colours. It is much easier to understand colour mixing when it is displayed in this circular fashion (shown opposite). At a glance we can see what a colour's opposite (complementary) is. Opposites can be used to neutralize or reduce the vividness of a colour. In varying amounts, complementary colours can be used very effectively to create contrast and harmony.

The complementary of an orange-red will be a bluer green. The complementary of a violet-red will be a yellower green. The complementary of a violet-blue will be a yellower orange. The complementary of a green-blue will be a redder orange. The complementary of an orange-yellow will be a bluer violet. The complementary of a green-yellow will be a redder violet.

Last Light, East Hardwick

To create the colours within this painting, I used a lot of ultramarine (violet-blue split primary) in the mixes which works nicely for snow. The grey sky was a mixture of ultramarine and burnt sienna (with a lot of water) and the snow colours were mixed with ultramarine and cadmium red or vermilion (orange-red split primary) with plenty of white, creating secondary blue-ish greys.

Oranges were mixed with cadmium yellow (orange-yellow split primary) and a tiny amount of either red split primary. The orange in the sky is quite yellow here and it makes a good contrast with the violet-blue, being a complementary of the orange-yellow. This is how the painting worked out and it's not important to worry about planning a picture in a theoretical way, but rather choosing colour mixes that appeal to you.

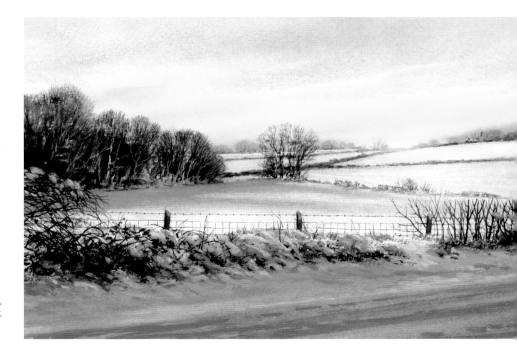

Mixing colours

Colour mixing requires great subtlety as it is so easy to add too much of another colour and unless you know how to correct it you can waste a lot of paint! Using the two colours below, you will see how you can mix bright, vivid greens.

Key tip

Before starting to paint a picture, test out the colours on a separate piece of watercolour paper to check the strength of the colours and to make sure that you like them. Use a small brush so that you don't use up all the paint in your palette!

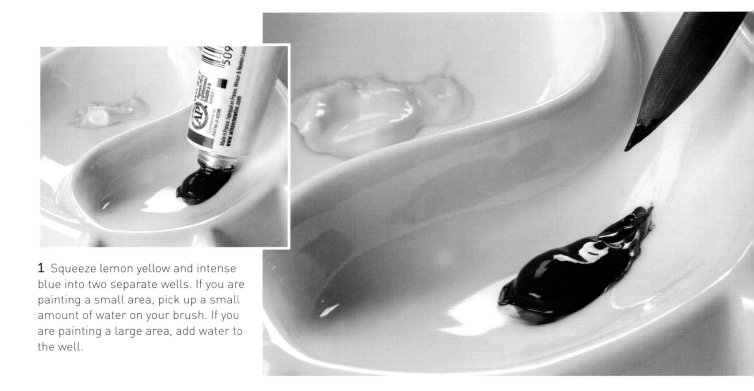

1 Squeeze lemon yellow and intense blue into two separate wells. If you are painting a small area, pick up a small amount of water on your brush. If you are painting a large area, add water to the well.

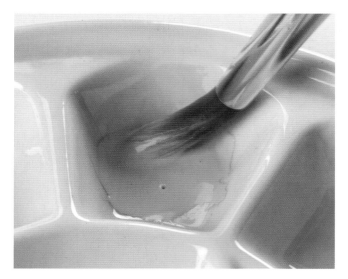

2 Add two to three drops of water into a separate well using your dropper. If you need a thinner consistency, add more water, as described in the section on preparing your paint (see page 16). Add a bit of yellow to the water well and mix thoroughly.

Key tip

Be careful when adding a darker colour to a lighter colour – quite quickly it can become too dark. Don't underestimate the strength of the darker colour.

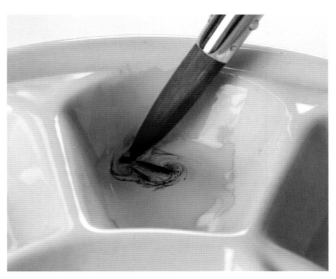

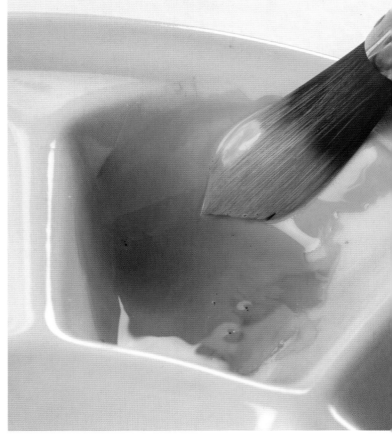

3 Add the intense blue to the lemon yellow a bit at a time until you get the green you are after. If you work the other way round, you can end up with a green that is too dark.

Key tip

Refresh your palette with a spray of water, to stop the paints from drying out.

Mixing different greens

As we have seen above, lemon yellow and intense blue (which is slightly lighter and brighter than Prussian blue) are colours that lean towards the green side of the spectrum.

Cadmium yellow and ultramarine lean towards the red side of the spectrum and would give us greens that are less bright. A different combination of one of the yellows and one of the blues, say cadmium yellow and intense blue, would give us slightly less vivid greens than lemon yellow and intense blue. Lemon yellow and ultramarine would give us moderately bright greens but not as bright as lemon yellow and intense blue. Cadmium yellow and ultramarine will give us less bright greens because they lean towards the red side of the spectrum and as green and red are complementary (opposite) colours, each will darken, dull or neutralize the other.

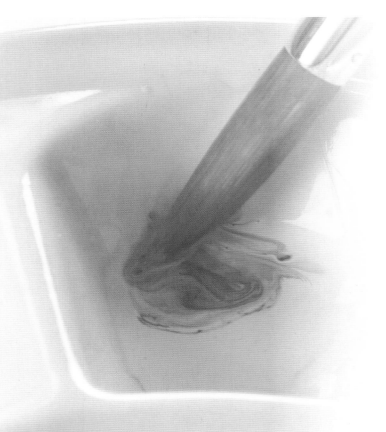

Colour swatches

The first swatch uses lemon yellow and permanent rose, with jet black and zinc white. This is helpful to see how we can achieve very subtle mixes that are fractionally different from those adjacent, and many people have little idea just how many variations can be created with only two colours, plus white and black. If you do this exercise, it also helps you remember what happens when you mix two colours together, and lighten and darken. If you do this in a sketchbook or notebook, you will have it as a handy reference when you come to paint a particular subject. Within nature there is so much subtle and extreme variation.

Making a colour grid

Discover how many colours and tonal variations can be created by gradually mixing two colours together, and adding white, or black.

1 On the top line in the middle, paint some lemon yellow.

2 One square to the left of it, paint lemon yellow mixed with a little zinc white.

3 One square to the left of that, paint lemon yellow mixed with a little more zinc white, and so on, so each square to the left has more zinc white added.

4 One square to the right of the original middle lemon yellow, paint lemon yellow mixed with a tiny amount of jet black.

5 One square to the right of that, paint lemon yellow mixed with a little more jet black, and so on, so each square to the right has more jet black added.

6 After the top line is finished and it has dried, on the bottom line in the middle paint some permanent rose and repeat the same process as with the lemon yellow, lighter to the left (with zinc white) and darker to the right (with jet black).

7 After this has dried, go back up, under the top lemon yellow line. Now create the second line down, starting in the middle, painting lemon yellow mixed with a tiny amount of permanent rose, then repeating the lighter tones to the left and darker tones to the right.

8 After that, go back down to the line above the permanent rose at the bottom and paint permanent rose with a tiny amount of lemon yellow. Continue the process to the left and right. Continue with each horizontal line until they meet in the middle.

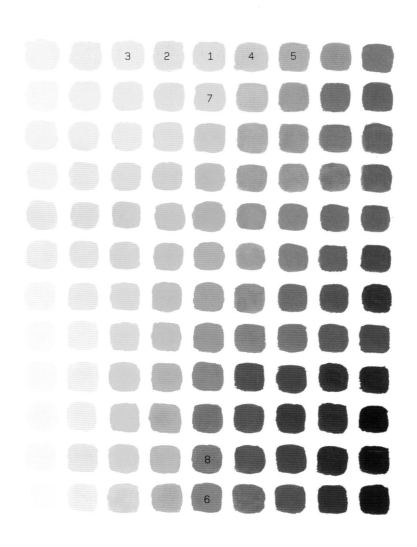

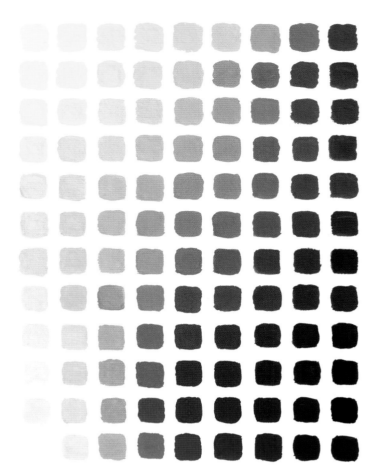

Another colour grid

Try the same process again, but this time with lemon yellow and ultramarine, adding increasing amounts of white to the left and black to the right.

The swatch here shows some of the vast range of colours we can mix just from two (a yellow and a blue) and the addition of white to those colours, and black, in different proportions.

This can be a very useful exercise for you to try, perhaps in a sketchbook or a notebook so you can use it for reference when mixing colours another time. With practice, you will find you can mix the colour you want more easily and quickly as a result of doing these exercises.

Mixing greens

The third swatch here shows cadmium yellow and Prussian blue, with increasing amounts of white to the left and black to the right. You can try this exercise with any two colours, and add white to lighten and black to darken.

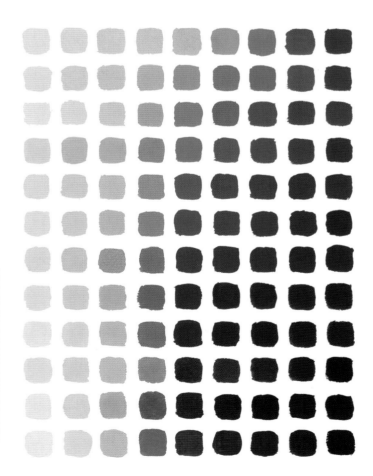

Key tip

If you try this, you will need to mix a good quantity of each central mix so that you can take a little to lighten each time, still having enough of each line's central colour to darken as well. If you are careful, you can see what a huge range of colours you can mix with just two, plus white and black.

Creating shadows

To give the impression of shadows, I mix a darker version of the colour that the shadows are falling across. For example, if a green-brown object like a tree has a darker side, I mix a darker green-brown, as can be seen in the painting below.

You need to observe shadows carefully, as inventing them will look unconvincing. Working only from photographs can be helpful for reference, but photographs do tend to exaggerate the darks.

Be careful to avoid just adding black for a shadow colour as it can easily look dead, flat and uninteresting. A little black may be used if black is preferred in your palette, but also, some darker colours may be mixed by adding the colour's opposite, or complementary colour. (For more on this, see the section on primary colours, secondary colours and complementary colours, pages 24–25.)

If there is strong light on an object, particularly something shiny, then the colour of that object can be less easily visible because of the reflected light. This is where observation is crucial in making a convincing rendering of a subject.

Key tip

If an object casts a shadow across something, the shadow colour will be a darker version of whatever it is falling across. In a landscape for example, I would not mix the same colour for the shadows falling across a road and grass, but mix a darker version of the grass colour(s) and also mix a darker version of the road colour(s). Blues, particularly ultramarine, work well in shadows, keeping them clean and fresh-looking.

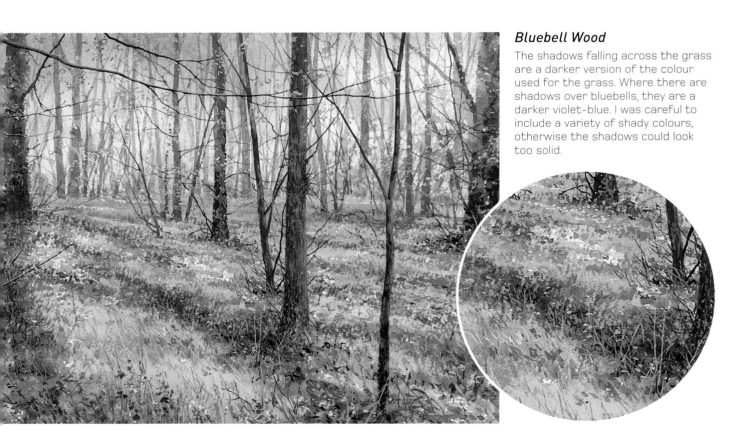

Bluebell Wood

The shadows falling across the grass are a darker version of the colour used for the grass. Where there are shadows over bluebells, they are a darker violet-blue. I was careful to include a variety of shady colours, otherwise the shadows could look too solid.

Creating three dimensions

In *Morning Milk*, there are not very obvious shadows as it's a duller day so any shadows are fairly subtle. There are, however, some key areas of darker colour and tone, particularly on the left of the posts, behind the churns and among the machinery. In each case, the shadows are a darker variation of the lighter colour.

If an object such as a milk churn is round, then I may mix the darkest colour of the shady side and the lightest colour of the light side and blend them gradually across the object, as you can see across the curve of the milk churn below.

Morning Milk

The three-dimensional appearance of a painting is all down to careful observation of subtle changes of tone. The darks around the churns, the machinery and the table make the light come forward, creating a three-dimensional effect.

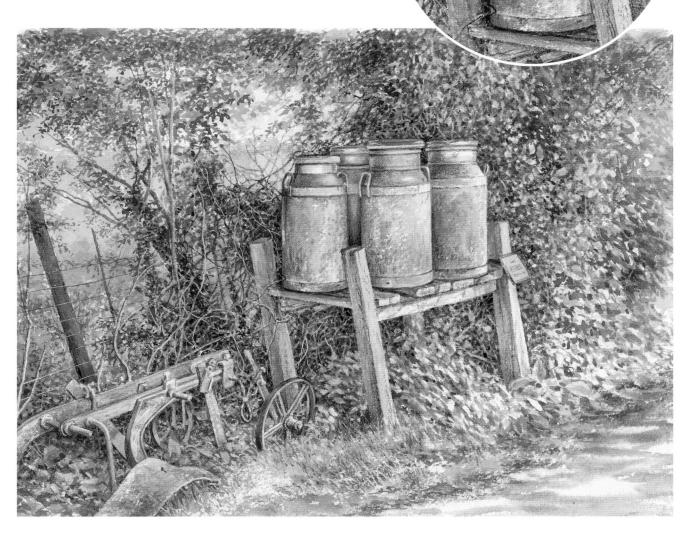

THE ART OF GOUACHE

Autumn Glory

Gouache techniques

By and large, the painting effects that are possible with gouache don't differ that much from other paint media, which means that you can use gouache to emulate other ways of painting. Gouache is a fantastically versatile and adaptable medium that is easy to use and allows you to combine traditional oil and watercolour techniques together in the same painting.

Absolute photographic realism, impressionism and many other styles can be depicted with those media as well, but gouache allows me the possibility of being able to overpaint and rework, many times if necessary. Acrylic lets me do this too, but gouache enables me to blend into colours which have already dried, which is only possible in acrylic with the interactive type of paints and a particular enabling medium. Oil paint can be reworked or overpainted when dry, but unless they are quick-drying oils or a drying oil is used with the oil paint, the artist may have to wait a good while for the oil paint to dry. Gouache dries within a few minutes and can be speeded up if necessary with gentle use of a hairdryer.

When gouache is applied reasonably thickly, it has a chalky look when dry due to the opaque nature of the paint. This can sometimes look a bit flat, particularly if there's not much interest within the painting. However, this chalky look is not noticeably problematic when a good range of colour and/or tones have been used. If a gouache painting is framed, the glass on the picture makes any chalkiness virtually irrelevant as it gives a depth to the overall painting that might be lacking in an unframed piece.

The same effect can be achieved when painting with acrylic paint where a chalk-finish medium or matt varnish has been used.

Near Dethick, Derbyshire
The colours throughout this painting were milky and creamy in consistency, painting from the background towards the foreground, overlaying colours.

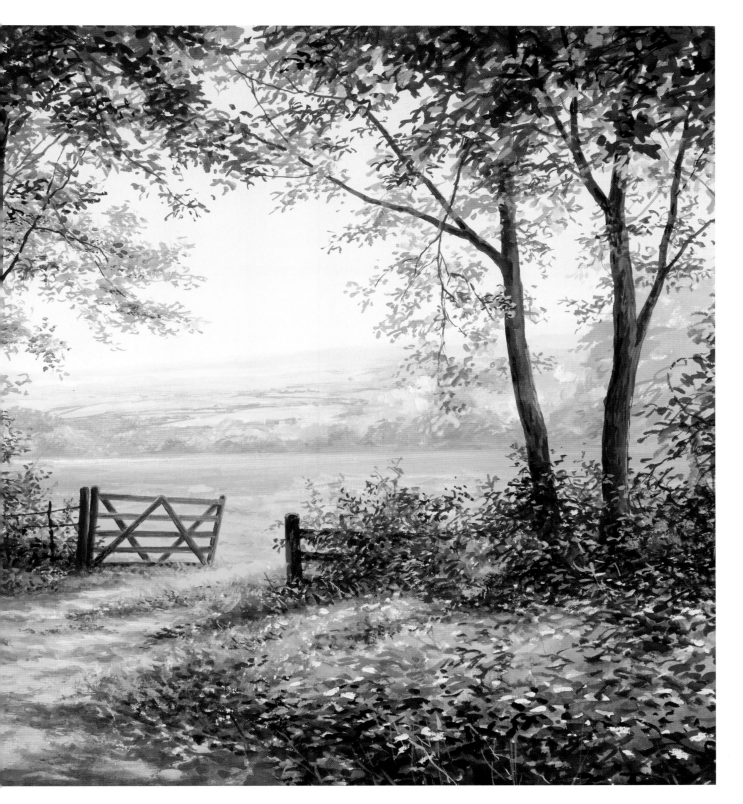

Washes

This is a universal technique, discussed on pages 18–19, but it can be done more thickly with gouache.

Most of this painting was done in a watercolour style, leaving bits of the white paper showing in the ripples in the foreground. Where any white paper was lost, I used thicker white gouache, for example, at the distant water's edge.

The sky was a very dilute gradated wash similar to watercolour painting on wet paper, with no paint in the area where I wanted white clouds. The contrasting blue gives the impression of hazy white clouds alongside. Once dry, a pale grey was painted on dry paper for the background trees as a fairly flat silhouette, paler with more water on the left, stronger to the right. While this was still wet, I dropped in the already mixed brown colours for the lower trees, down to the water's edge.

After the area above the river was dry, the water area was wetted, only down to the rippled area, then I dropped in the same tree colours as above. Once this had dried, vague broken reflections were added on dry paper. Next, I added the ripples with short, fairly horizontal brushstrokes, gradually darker and darker. If any white was needed, this was added to the ripples at the end.

After this had dried, slightly stronger gouache was easily applied for the trees on the left, the more distinct trees painted with a very fine brush.

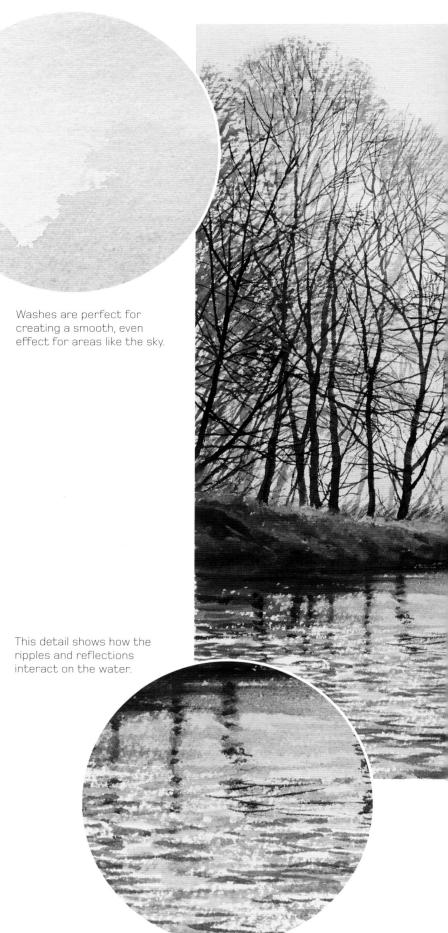

Washes are perfect for creating a smooth, even effect for areas like the sky.

This detail shows how the ripples and reflections interact on the water.

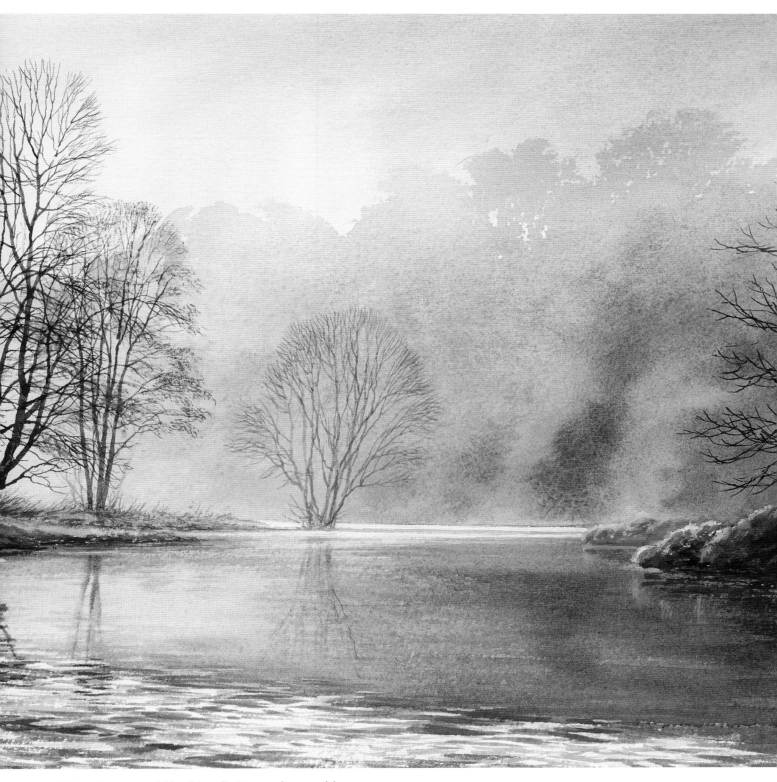

River Darwen at Hoghton Bottoms, Lancashire

Spattering

Use this technique to add a bit of texture to your painting, or some finishing touches.

Make three colour mixes, all in a milky consistency. You can achieve this by adding water to the paint colours. Start by mixing burnt sienna and intense blue together to give a very dark green. If you want it to be darker, you can add a small amount of black. Next, mix a dark brown using burnt sienna and black. For your third colour, use permanent rose and intense blue to give a violet. I use a size 10 round brush.

If the spatter looks too heavy or you make a mistake, mop it up immediately with kitchen paper. If you want a wider area of spatter, use a larger brush. The larger the brush, the less control you will have over the area of spatter.

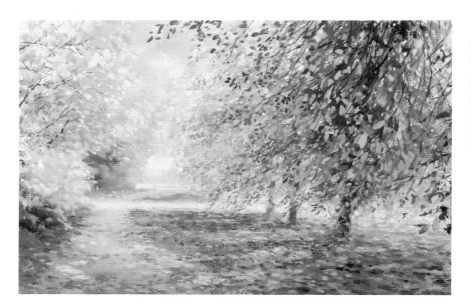

Dando Way, Ackworth
Here is the painting before any spattering was added. I felt that it was lacking something and I thought that adding some spattering would introduce contrast and add more interest. You can see the finished painting opposite.

 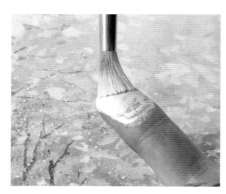

1 Load the brush with plenty of paint. Flick the brush against the tip of your forefinger on the other hand. If this is a new technique, practise on a piece of paper first. You can do this technique using the end of a brush instead of your finger, but I find that the paint tends to collect underneath and can splash onto the paper unexpectedly, making a mess.

2 The paint will spatter off your finger onto the painting underneath. Angle your brush accordingly, depending on the way you want the paint to fall. For the ground to look flat, make the spatter horizontal by flicking the brush off your finger horizontally.

3 Add a small amount of intense blue to the lemon yellow for a final touch of spattering to the tree on the right and some zinc white to the blossom.

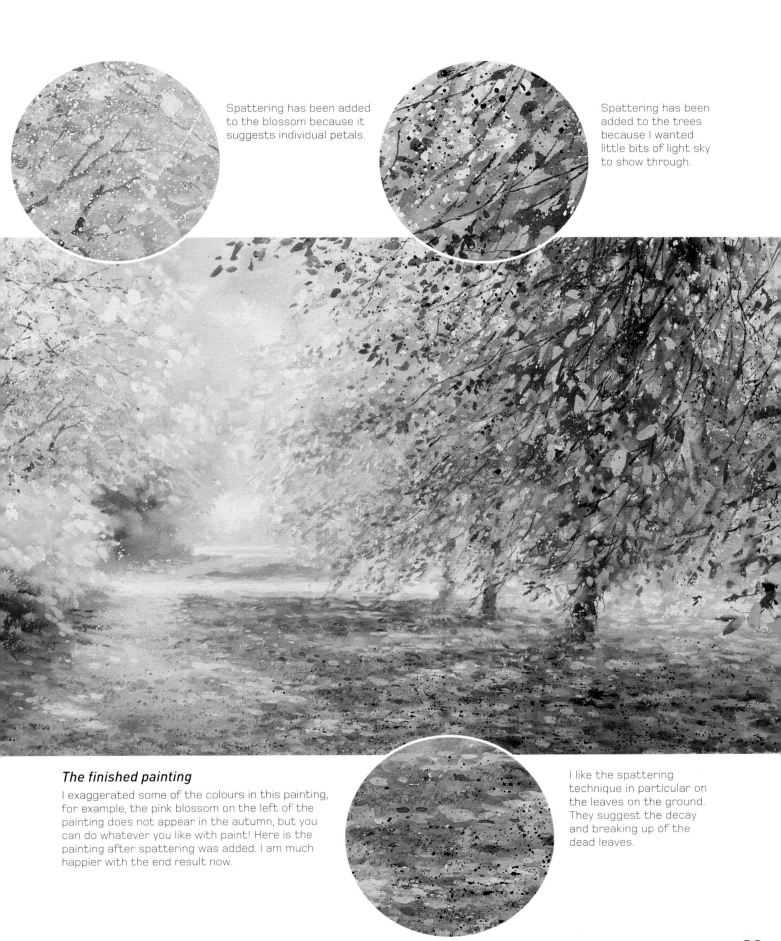

Spattering has been added to the blossom because it suggests individual petals.

Spattering has been added to the trees because I wanted little bits of light sky to show through.

The finished painting

I exaggerated some of the colours in this painting, for example, the pink blossom on the left of the painting does not appear in the autumn, but you can do whatever you like with paint! Here is the painting after spattering was added. I am much happier with the end result now.

I like the spattering technique in particular on the leaves on the ground. They suggest the decay and breaking up of the dead leaves.

Wet blending

Blending is a widely used technique, particularly in oils. Gouache offers its own advantages, for example, if the paint dries before you want it to, you can rework it with the damp brush. This is an advantage of gouache over acrylic. Gouache also dries much faster than oils, allowing you to carry on painting.

Using permanent rose, cadmium yellow and white, create an orange mix of a creamy consistency. If the mix is too watery, the colours will flood into each other.

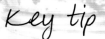

Key tip

Whenever you paint on wet paper and it's drying too quickly with the shine already gone from the paper, you can spray some water onto the paper to make it damp again.

1 Paint a horizontal line of orange from one side to the other, onto dry paper.

2 Paint a horizontal line of yellow underneath, so that it just touches the orange.

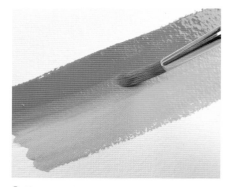

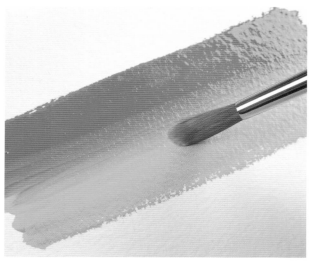

4 To soften where the colours meet, remove all colour from the brush and use a damp brush backwards and forwards.

3 Dry your brush on some kitchen paper, then work some of the orange into the yellow and some of the yellow into the orange, trying to get as smooth a blend as possible.

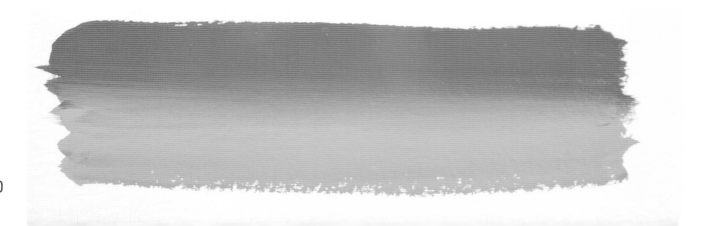

Dry blending

Dry blending is softening an area of painting that has dried, in order to create a soft, smooth effect, for example to soften a hard edge. This gives the artist the freedom not to worry about softening or blending while colours are wet or damp. Two or more colours can be painted alongside each other and blended into one another when dry with a clean, damp brush. Dry blending is virtually impossible with other paint media and is a great strength of gouache.

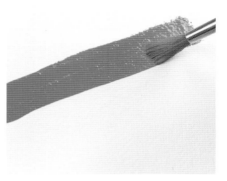 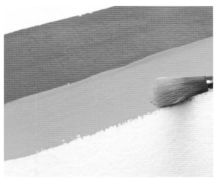 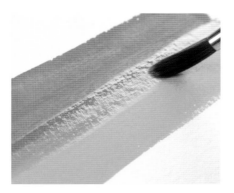

1 As described opposite, paint a horizontal line of orange onto dry paper. This time, allow the orange to dry, or use a hairdryer to dry it.

2 Next, apply a horizontal line of yellow and allow to dry. You will now have a hard edge between the two colours.

3 Use a damp brush (not very wet) and where the two lines meet draw your brush along the join to work each colour into each other. If you collect too much paint on your brush, wipe it on kitchen paper. This gives the same result as wet blending.

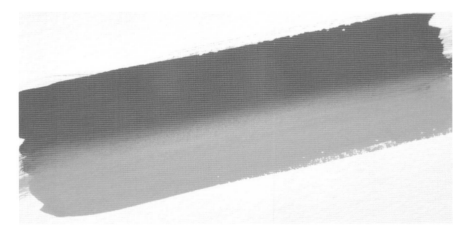

Dry blending
The colours have been softened together with a damp brush on the dry paint so that they blend.

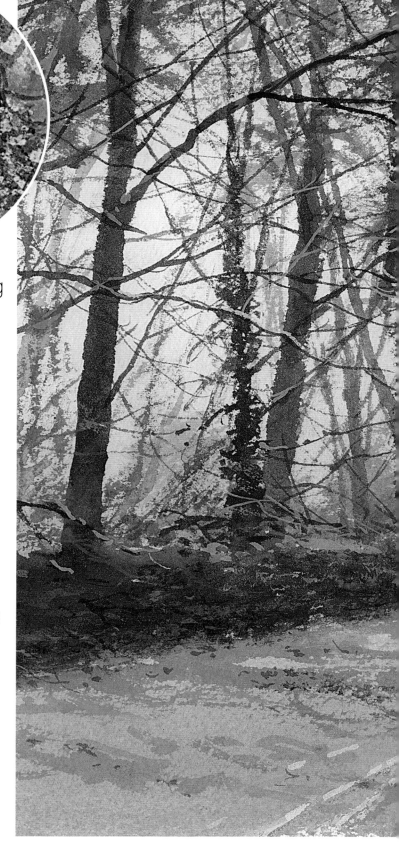

Using blending in your painting

The sun here is a focal point. It is important to the composition because the eye is attracted to the vibrancy of the brilliant sun shining through the trees. Without it, the scene would still be a pleasant one, but rather empty.

This dazzling sunlight is the ideal example of the use of blending. Apart from the pale grey down to orange blended colours in the sky, which was painted in a watery way like watercolour, there is little blending elsewhere apart from a little in the immediate foreground (grey and white) underneath the tracks.

I usually start with the sky and work downwards, which means painting from the background towards the foreground. I started with fairly watery colours then, as I progressed, I added thicker colours for trees, snow and shadows. The sun was painted after the sky and trees, so I needed to use fairly strong paint. It doesn't matter whether the glow around the sun is painted using wet or dry blending.

Winter's Glow

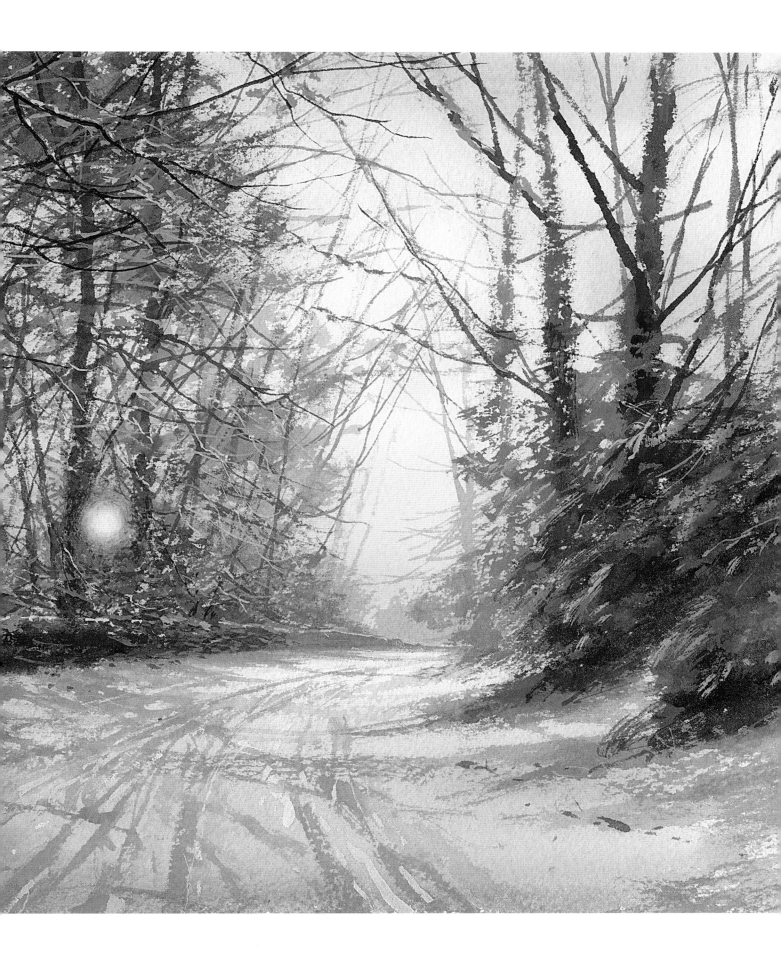

Using plastic food wrap to create a striking effect

This is a watercolour-type technique which is not solely limited to gouache. I use it to create texture, effect and interest in semi-realistic floral pictures. It would not work quite so well in a traditional-style landscape picture, because the pattern it makes could be distracting.

Any colour paints with plastic food wrap will create the kind of patterns you can see here and the stronger the colours used, the more obvious the patterns will be.

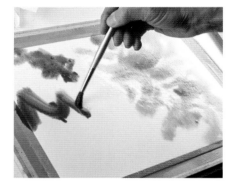

1 Cut enough plastic food wrap to more than cover your painting board. Wet the paper all over using a large hake brush. While the paper is wet, drop pre-mixed watery colour in at the top of the painting, and a little bit thicker lower down, using a size 10 brush. Apply in an uneven way.

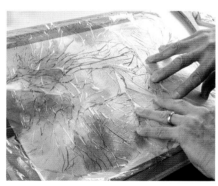

2 Place the sheet of plastic food wrap over the painting board while the paper is still wet and scrunch it up with your fingers so it doesn't lie flat.

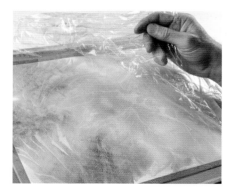

3 Wait for the paint to dry and then remove the plastic food wrap.

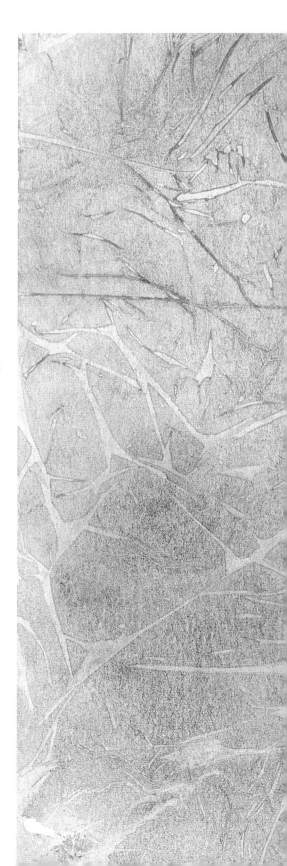

Nest Eggs

Here I used straw colours, ochres, greys and browns to create a subtle effect, not wanting the colours to be too strong or obvious. The contrast between the semi-abstract background, made using the plastic food wrap technique, and the more detailed eggs makes for a strong result. Gouache allowed me to paint over the background completely, so there was no need to leave a gap.

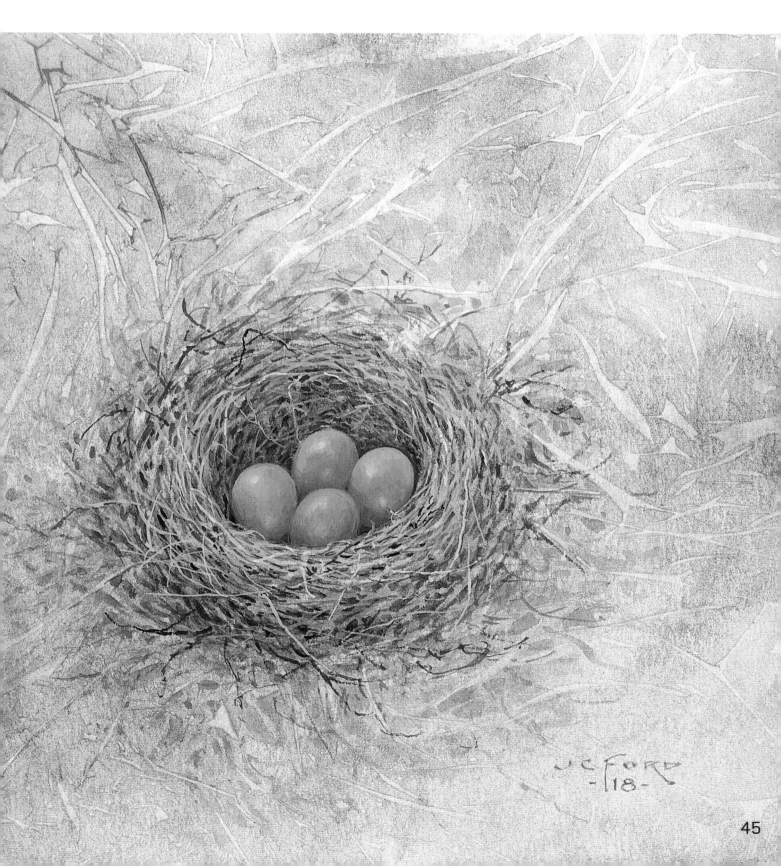

Using brushstrokes to create different effects

Dry brush

This technique is particularly good for creating different textures, e.g. foliage and stones. You need a strong tone with hardly any water and a damp brush. Using a textured/rougher paper (Not paper or Rough paper) makes this easier.

Synthetic brushes are easier than sable brushes for this as they are slightly stiffer and springier. I find this technique harder to achieve with a sable brush. Sable brushes are best used with very wet paint as they hold more wet paint than synthetic brushes.

1 You need the paint to be damp in consistency.

2 Remove excess paint from your brush on kitchen paper.

3 Using the whole body of the brush (not just the tip), dab the paint onto the paper.

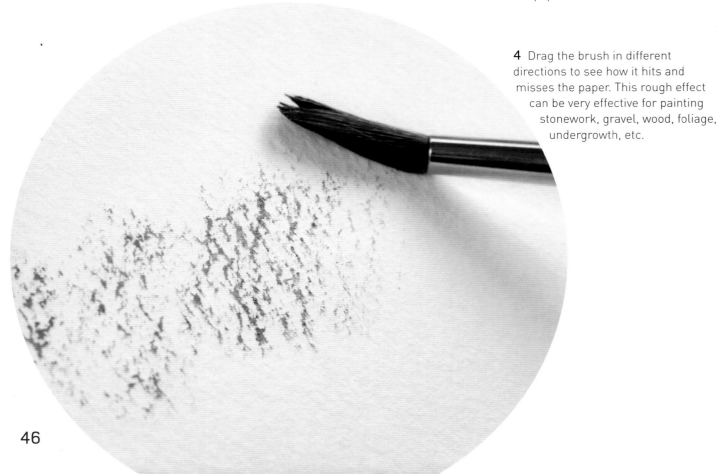

4 Drag the brush in different directions to see how it hits and misses the paper. This rough effect can be very effective for painting stonework, gravel, wood, foliage, undergrowth, etc.

Splitting the brush

This technique works well for painting fur or hair in an illustrative style. You need a damp brush, but don't use so much water that it holds the bristles together.

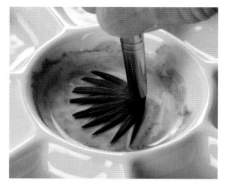

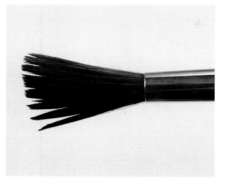

1 Use paint in the well with hardly any water in. Push the brush back on itself.

2 When you lift the brush up, you can see that the bristles have separated. The brush will work its way back to its natural shape, so keep pushing it back on itself in the palette.

3 Gently caress the paper with the split brush, allowing the bristles to create the effect you want.

Dragging the brush

This technique is good for painting woodgrain, winter trees, twigs and branches.

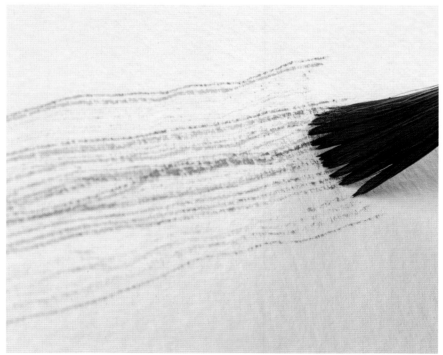

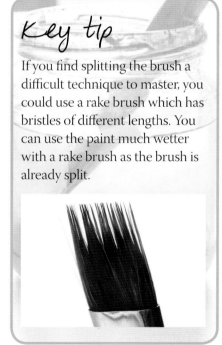

Key tip

If you find splitting the brush a difficult technique to master, you could use a rake brush which has bristles of different lengths. You can use the paint much wetter with a rake brush as the brush is already split.

It is important not to press hard when using the split brush, otherwise you may end up with a completely different brushstroke! Always try it first on a bit of spare watercolour paper.

Overlaying

You may find that you frequently need to paint over a previous layer of paint, either to alter it or to get rid of it, and it is all too easy to disturb the underlying colour without meaning to. Consistency of paint is important in this respect.

If the underlying colour shows through when you don't want it to, let it dry and go over it again, possibly with stronger, less watery paint. The great advantage of gouache is that you can go over and over multiple times, so keep going until you get the effect you want.

Below I painted a layer of green then tried to paint on top of that with yellow. You can see the layer of yellow which is patchy and uneven. The paint underneath can easily be disturbed, particularly if it hasn't dried properly, and also if the top layer is not applied generously enough. You can use a hairdryer to dry the layers then go over it again.

Key tip

When overlaying, if you want to completely cover the layer underneath, make sure the first layer is totally dry and don't make the second layer too watery. Instead, it should be a creamy consistency.

The top layer is disturbing the layer underneath.

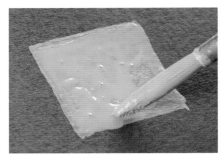

1 To correct this, allow the yellow layer to dry. Apply more yellow paint of a creamy consistency to cover the green paint that showed through.

2 Trying not to disturb the layer underneath with repetitive brushstrokes, gently smooth out the newly added yellow paint. If you find you are agitating the layer underneath, stop, dry it with a hairdryer and apply more yellow paint as before, until you achieve a smooth finish.

Successful overlaying

As long as the colours are thick (of a creamy, or double cream consistency), they will cover a dry previous layer, although sometimes a second or even a third coat may be necessary.

The images to the right show two examples of successfully overlaid gouache – the left one shows dark paint over light; the right image shows light over dark. The latter example is something almost impossible to achieve in watercolour.

Opposite:
Dried Hemlock with Grasses
Once the background had dried, thick but fluid mixtures of the plant colours were then painted over the top.

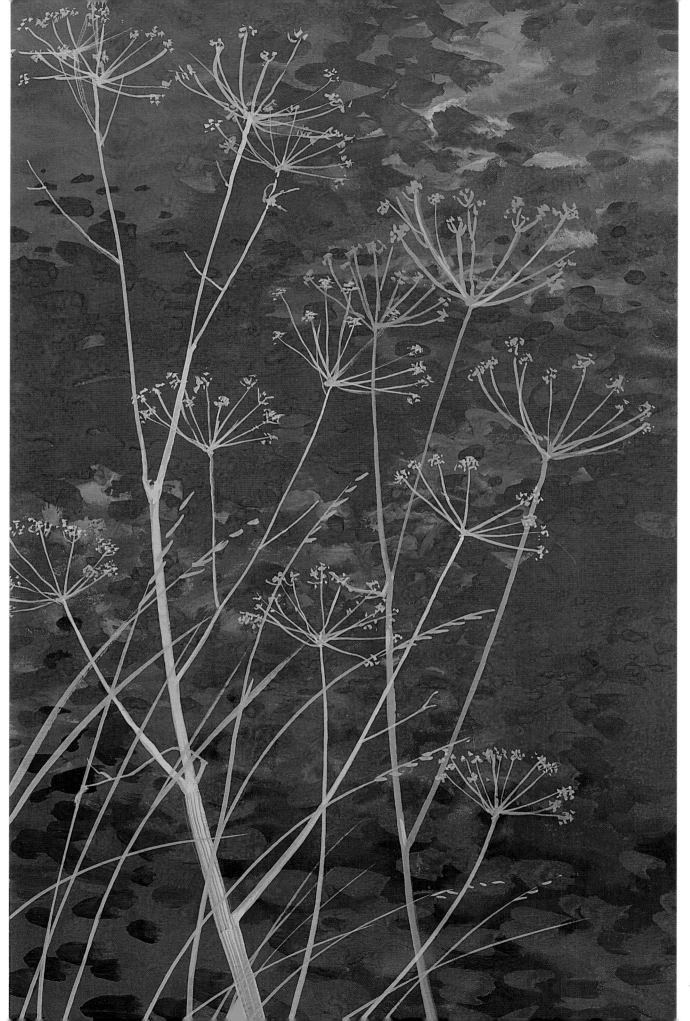

Using overlaying in a painting

This technique can be used to add flat layers without disturbing the paint underneath. This is critical for the smooth finish this style demands. Use the flat wash technique to achieve a smooth finish (see page 18). The sequence doesn't matter: you can add a dark colour on top of light, or a light colour on top of dark. I am using cadmium yellow with ultramarine.

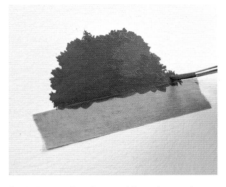

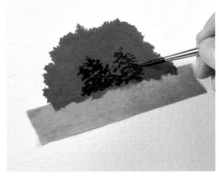

1 Using a size 6 round brush, apply paint of a creamy consistency in a block of colour. Add a strip of masking tape underneath, ensuring it is securely stuck down at the top edge. This will create a clean edge when you remove it.

2 Wait for the paint to dry. Ensure the second layer is of a similar consistency to the first layer, if not a bit thicker. If it is too watery, it will disturb the first layer. Try to avoid agitating the colour underneath. If it starts to be disturbed, stop and dry it with a hairdryer.

3 Repeat with the trees for the third layer.

4 Remove the masking tape slowly and carefully to reveal the finished painting.

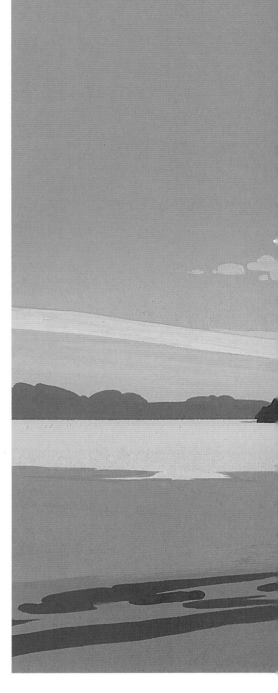

Key tip

Test out the colour on a separate piece of paper to make sure there is enough contrast.

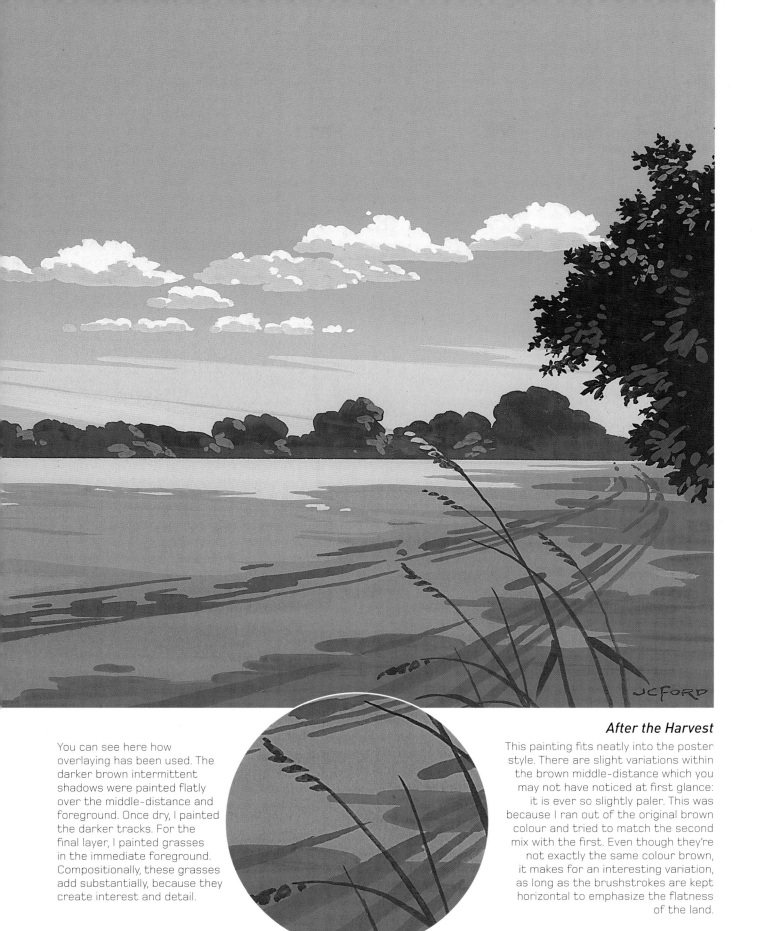

After the Harvest

This painting fits neatly into the poster style. There are slight variations within the brown middle-distance which you may not have noticed at first glance: it is ever so slightly paler. This was because I ran out of the original brown colour and tried to match the second mix with the first. Even though they're not exactly the same colour brown, it makes for an interesting variation, as long as the brushstrokes are kept horizontal to emphasize the flatness of the land.

You can see here how overlaying has been used. The darker brown intermittent shadows were painted flatly over the middle-distance and foreground. Once dry, I painted the darker tracks. For the final layer, I painted grasses in the immediate foreground. Compositionally, these grasses add substantially, because they create interest and detail.

Overcoming common problems

Amount of paint

Always mix plenty of paint for a given stage of a painting, particularly if you want a flat and even colour as you may not be able to mix exactly the same colour again with ease. I always think it's best to have too much paint rather than not enough, and often what may be left over can be used elsewhere in another mix.

Masking tape

Here I used masking tape to try to create a hard edge to the left and right. It didn't work as successfully as I had hoped. This was either because the masking tape wasn't stuck down as firmly as it should have been, or the rough textured paper allowed a tiny amount of paint to creep underneath. A smoother type of paper surface would make it easier for it to work well.

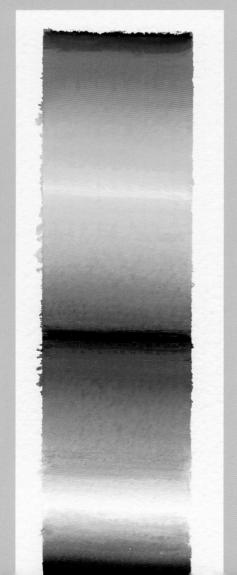

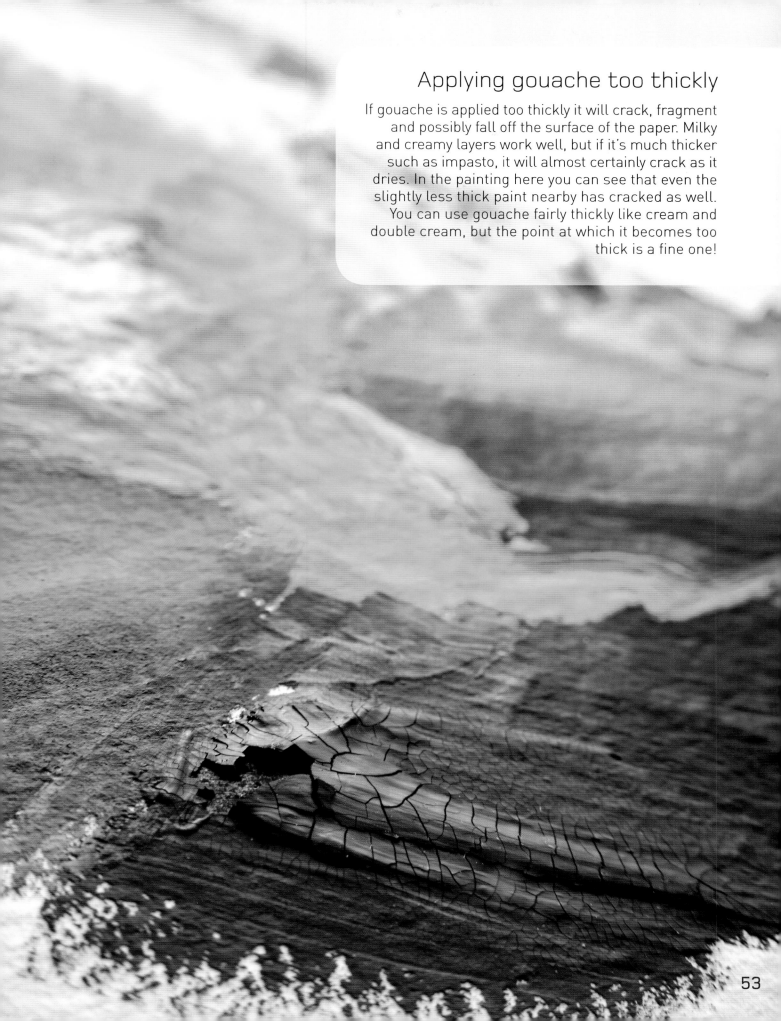

Applying gouache too thickly

If gouache is applied too thickly it will crack, fragment and possibly fall off the surface of the paper. Milky and creamy layers work well, but if it's much thicker such as impasto, it will almost certainly crack as it dries. In the painting here you can see that even the slightly less thick paint nearby has cracked as well. You can use gouache fairly thickly like cream and double cream, but the point at which it becomes too thick is a fine one!

Project: *Rosebay Willowherb*

Rosebay willowherb is a plant found in the northern hemisphere, particularly in disturbed places. Sometimes called 'Fireweed', it has purplish pink flowers in the summer. I painted it in the autumn when the fluffy seedheads had started to appear.

This project will let you practise and master some of the techniques we discussed above, such as wet-on-wet watercolour technique, overpainting using gradually thicker paint, and spattering for dramatic effect, to produce a stunning flower painting, full of vibrant colour.

Photograph of summer-flowering Rosebay willowherb.

Key tip

When changing from a lighter colour to a darker colour you don't always need to wash your brush. This can save you valuable time.

Opposite:
The finished painting

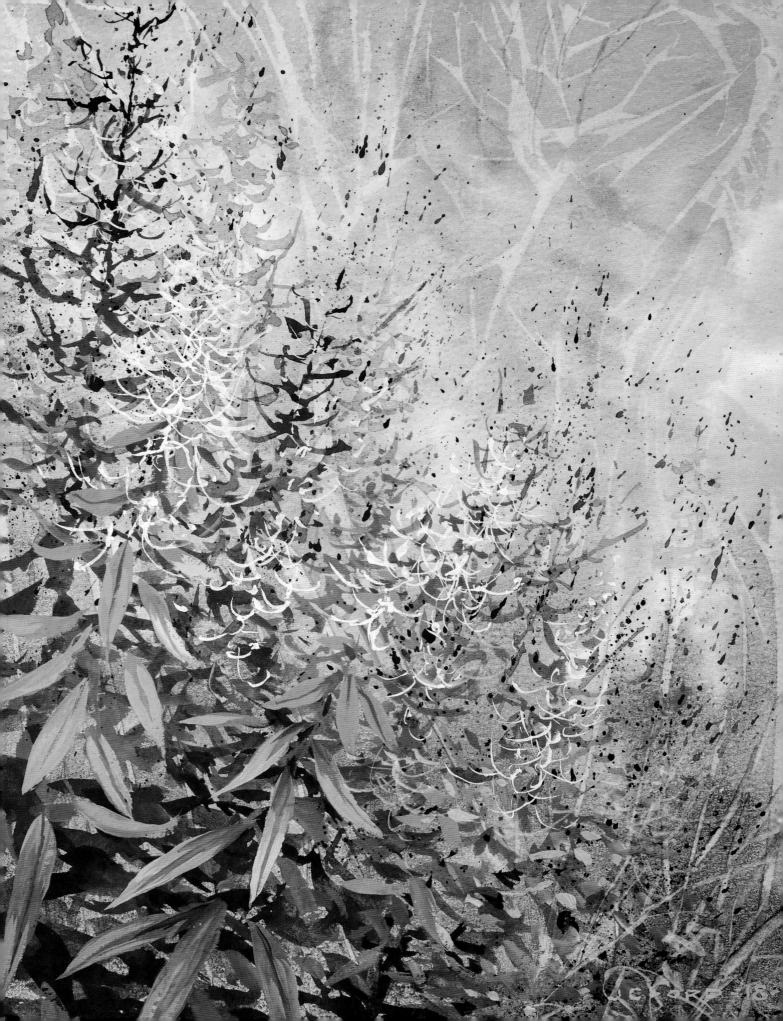

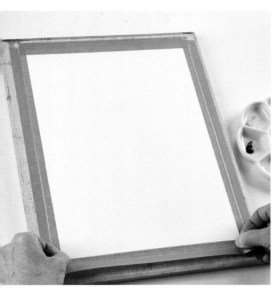

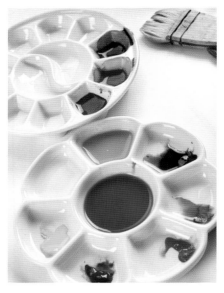

2 Prepare burnt sienna, permanent rose, cadmium yellow and jet black, all in a milky consistency. Prepare intense blue to a watery consistency. Make a light green mix of cadmium yellow with a small amount of intense blue, in a milky consistency. Make a second mix of dark green in a milky consistency, using burnt sienna and intense blue. Make a third mix of dark brown, using burnt sienna with a small amount of jet black. Make a fourth mix of dark violet, using intense blue, permanent rose and a small amount of jet black.

1 Use masking tape to secure the watercolour paper onto the drawing board, ensuring a 1cm (½in) border around the edge. Turn the board so that you are working portrait, not landscape.

Key tip

If you are working with wet paint on wet paper, always test the different colour mixes on a spare bit of wet watercolour paper to ensure they are correct. If you are working with wet paint on dry paper, always test the different colour mixes on a spare bit of dry watercolour paper.

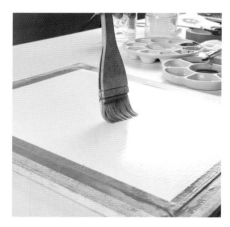

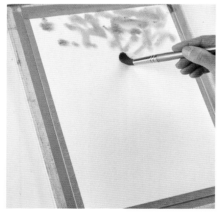

3 Wet the whole paper using a wet hake brush. Make sure you can see the shine over all the paper, as this ensures there are no dry areas that you have missed. It is important to work very quickly, as all the colours need to go on the paper while it is still wet. The plastic food wrap won't work if the colours have dried.

4 Pick up the watery intense blue with the size 16 brush, starting at the top of the paper and working down as quickly as possible before the paper and paint dry out. Try not to spend too long in one area.

Key tip

Try not to overload your brush, otherwise the paint will run and become uncontrollable. Use a loose, light dabbing motion to apply 'blobs', leaving some gaps on the paper. This avoids one colour dominating another.

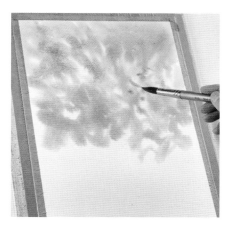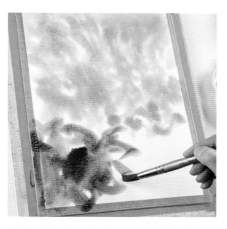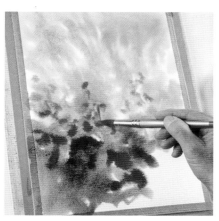

5 Add in the light green mix, working wet in wet and blending in some of this mix with the blue. Allow the blue and the green to merge. Take the light green down two-thirds of the paper. Add a touch of yellow.

6 Work in the dark green mix in the bottom third of the paper, particularly on the left.

7 Quickly add blobs of the dark brown mix, restricting them to the lower half of the paper.

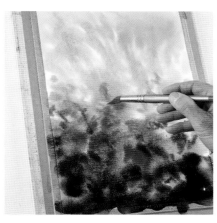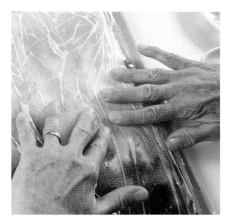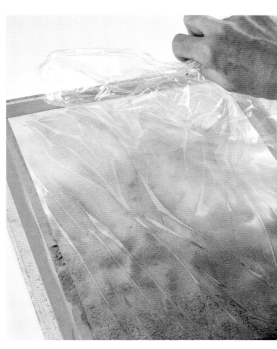

8 While all the paper is still wet, add the purple mix in the same way. Ensure that all of the paper is covered, giving you a complete background. The broad sections of the background are the sky, sunlight and shadows.

9 Quickly lay the plastic food wrap over the top and gently scrunch it with your fingers (see page 44), paying particular attention to the top of the paper. Using the plastic food wrap, form long vertical shapes with your fingers to indicate stems.

10 Allow the paint to dry, then carefully remove the plastic food wrap.

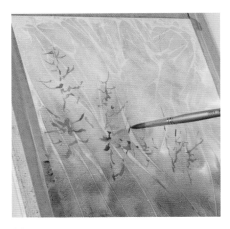

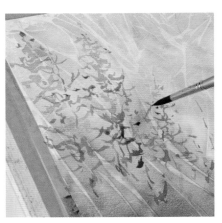

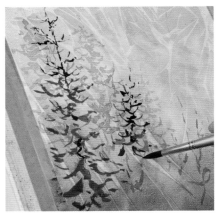

11 Combine some of the two green mixes to create a mid-green. Using the point of the size 10 brush (or the size 6 brush) with the mid-green mix, create some shapes in the sunlight area that suggest background foliage. Try not to be too accurate or fussy.

12 Make a watery mix of intense blue with a touch of permanent rose to create a pale, watery purple. Intersperse this with the foliage, again trying not to be too neat. Allow your brush to wander in the sunlight area remembering that your brushstrokes don't have to connect to each other or be continuous.

13 Still using the size 10 round brush, now paint mid-ground foliage in the same way, but using a thicker consistency by adding more paint to your mixes. Make a new mix by adding cadmium red to burnt sienna, giving you a rusty red mix (of a milky consistency). If you are not sure about the colour mix, try it out on a spare piece of dry paper. Add more brushstrokes, not too precise or neat, using the rusty mix, interspersed with the background foliage.

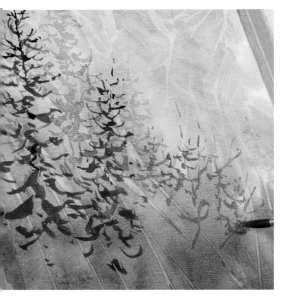

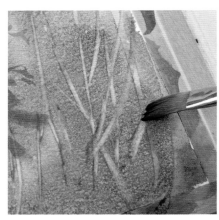

14 Continue to build up the foliage in the mid-ground in the same way. I have varied the rusty mix slightly by adding cadmium yellow. You can do this for all your mixes, to avoid one colour dominating the picture.

15 To create some interest in the bottom corner, use a damp flat brush (12mm) to gently agitate the paint. By lifting it out, you can create lines which give the appearance of stems.

16 Use kitchen paper to remove the damp paint and leave the impression of stems. You can use the flat brush to exaggerate the areas defined by the plastic food wrap if you wish.

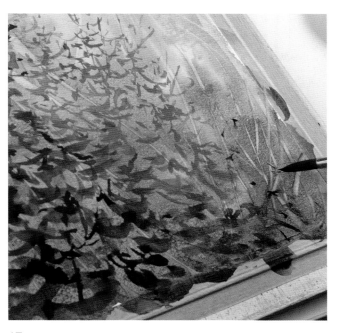

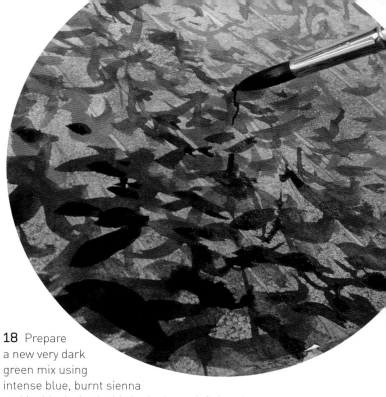

17 Using any of the dark mixes in your palette and your size 10 round brush, make slightly bigger strokes in the bottom third of the painting to indicate background leaves.

18 Prepare a new very dark green mix using intense blue, burnt sienna and jet black. Apply this in the lower left-hand corner on top of the background leaves. This provides a contrast to the foreground light leaves which we will paint next.

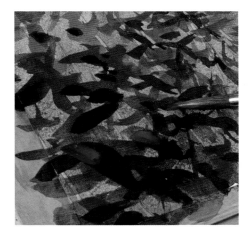

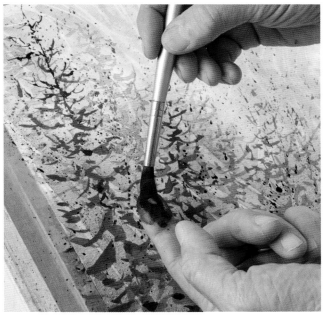

19 Add some cadmium red directly onto the wet, dark leaves, allowing it to mingle with the other leaves. This adds variety of colour and suggests autumnal leaves.

20 Using a diluted dark green mix and your size 10 round brush, create the impression of seed heads by adding some pale spattering, avoiding making big blobs (see page 38). Allow to dry, then repeat the process with your very dark green mix, being careful not to overdo it. Leave to dry.

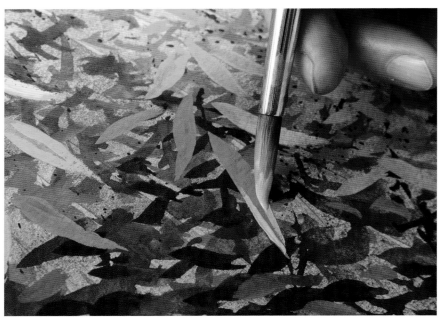

21 Using cadmium yellow and cadmium red, mix a thick yellowy orange. Create small leaf shapes towards the top of the plants and larger shapes towards the bottom, being careful to vary the angles as this creates interest and portrays natural variation. If the colours are not as bright as you would like, add some white to make them stand out better. I have done this to create two different orange mixes: one more pinky and the other more yellowy.

22 Using a creamy version of the light green mix, create some green leaves. To accentuate parts of the leaf, add more yellow and white to the mix and paint some of the edges with this.

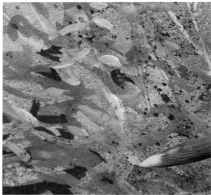

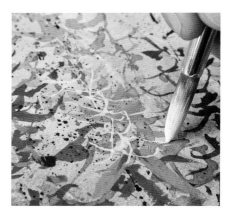

23 Add larger leaves lower down, using the rusty colours in your palette. These look larger because they are closer to us. Again, highlight some leaves by adding white or yellow to the basic colour in the palette and painting along the edges. This adds contrast and makes the leaves more eye-catching. I haven't painted stems for the leaves at the bottom, but they look like they originate from the same stem.

24 Add some layering by painting a few thick, yellow highlights to occasional leaves, particularly on the right. It is possible to paint them over the dark background because of their opacity.

25 Take some white paint in a thick consistency (although thin enough to flow from your brush) and use thin, curly strokes to create the wispy, cotton-like hairs at the top of the stems. If you want to suggest more distant hairs, you can use a subdued white by adding a touch of water. This gives some subtlety.

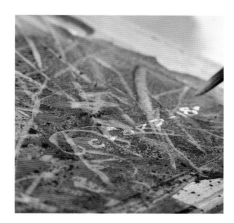

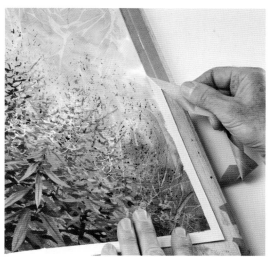

26 Add your signature and the year if you want, then leave to dry before carefully removing the masking tape.

27 Always remove the tape by pulling it away from the painting. If you pull it off towards the painting, it is possible the paper will tear inwards towards the paint.

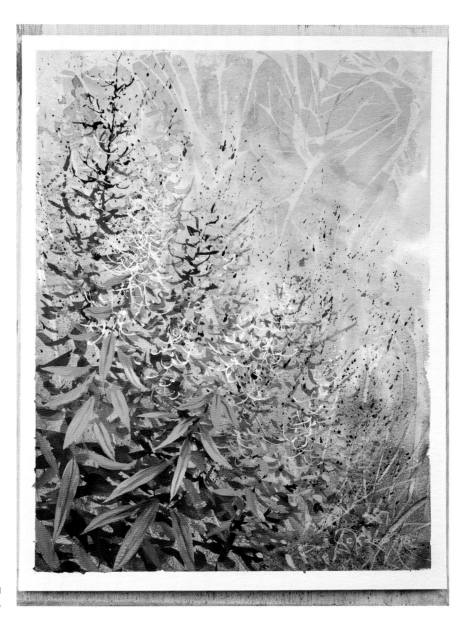

You can see the finished painting on page 55.

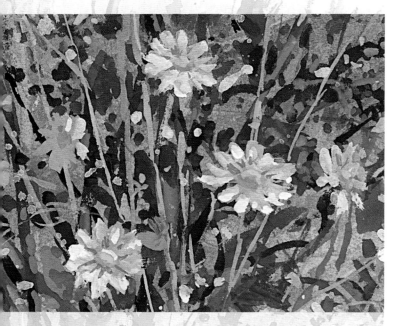

Harvest

This painting was produced using similar techniques to those in the *Fireweed* project. I used the plastic food wrap to create the impression of dry grasses, dry stems and stalks of dead vegetation. I think it works well in such arrangements and could also perhaps be suggestive of cobwebs if the pattern is right.

Once the background had dried and I had removed the food wrap, I started to paint the violet colours and the greens, then gradually overpainting from the background into the foreground. Spattering was also used to suggest seedheads and a certain spontaneity.

Although the daisies were painted last, they don't need to be. The sequence is not really important because with gouache you have the ability to paint over dry colour, whether dark or light.

Notice how the plastic food wrap was gathered from the sides to make patterns which are generally upright.

Also note that the brushstrokes for the stems of vegetation don't have to connect. An overall impression is created in a loose and free way, without it having to be botanically precise.

Behind all this in the background is the violet which, when dry, was painted over with the very dark tones. When that was dry, the daisies and their stems were added with thicker, stronger light colours. Note also that the petals vary in tone, the blue-grey petals appearing further away than the white ones catching the light, to give a three-dimensional impression.

Opposite:
Harvest

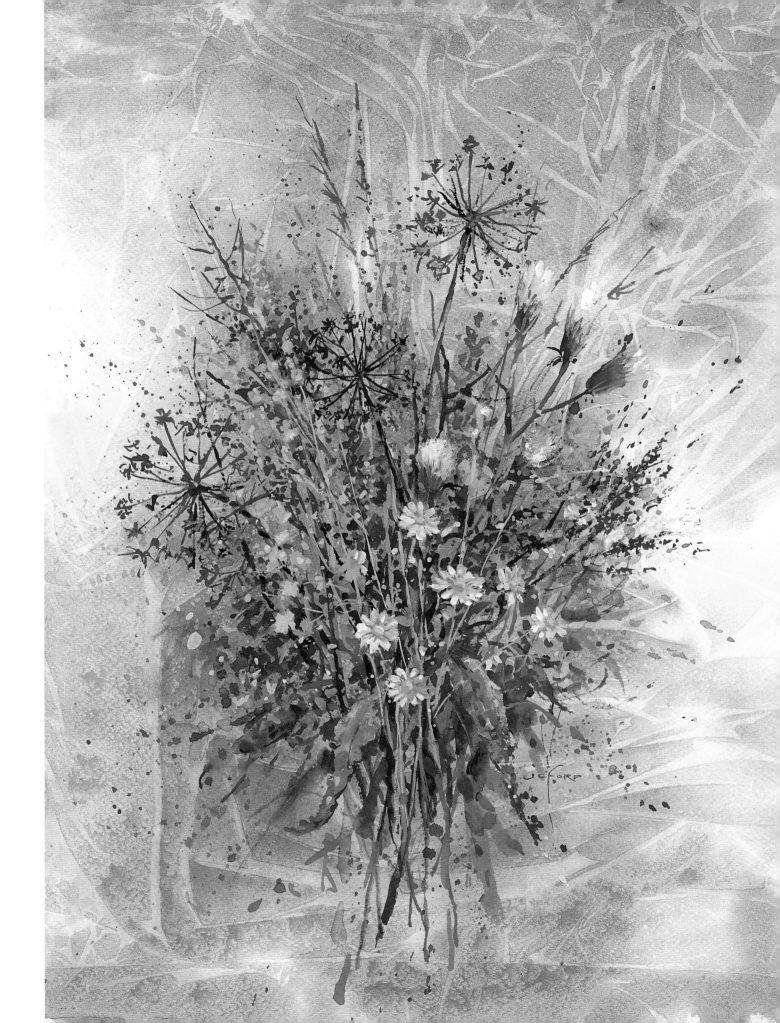

Flowering Rosebay Willowherb

The first stage was done by dropping all the colours I had already mixed onto the wet paper and working quickly before the paper had a chance to dry. This gives a soft effect. I wanted to suggest an out-of-focus background, and working quickly in this wet, soft way was the best method for me to achieve this.

Once this first stage was dry, I painted the individual flowers from the top downwards, building up layers of colours. I don't think it would matter if you worked from the bottom of the flowers upwards, as anything unsatisfactory can be worked over again. Finally, I spattered lemon yellow all over, then when that dried I spattered zinc white in the same way (see page 38).

First stage of painting.

Opposite:
Flowering Rosebay Willowherb

The dark background colours and tones give the picture a real depth, so that the light colours and tones advance and stand out well. The spattering was an afterthought; I think it adds a bit of drama and sparkle to the painting.

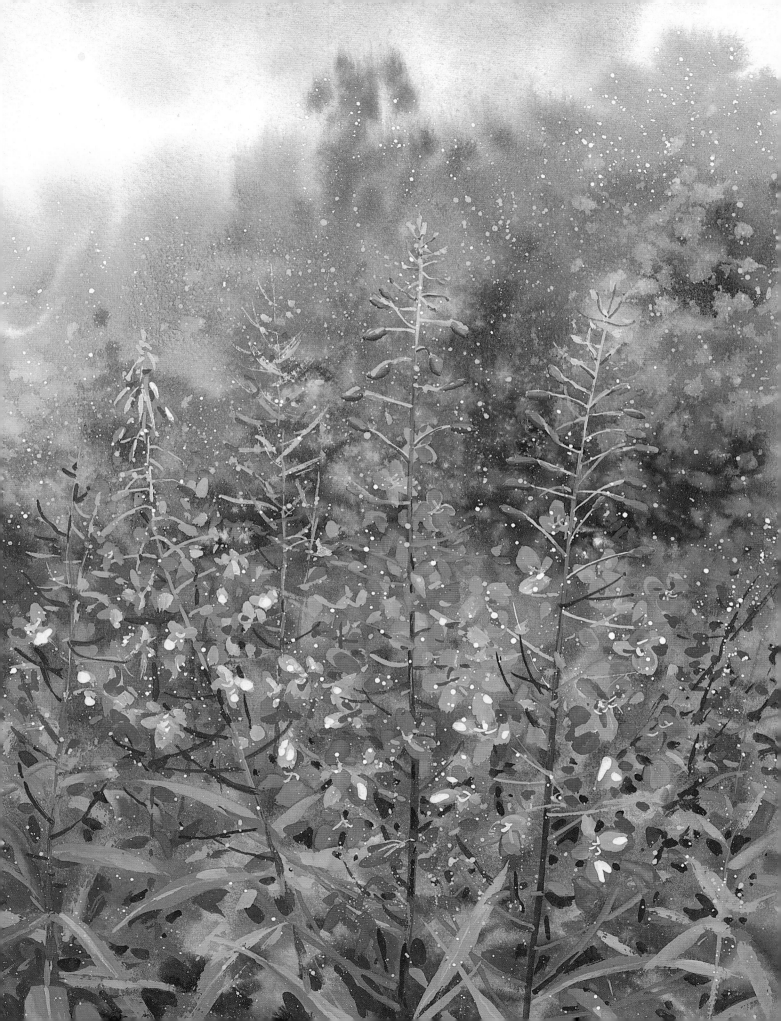

CREATIVE

GOUACHE

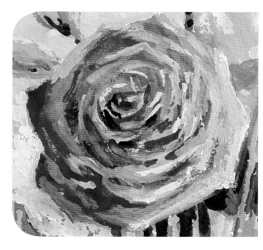

Gouache is a very versatile medium. Henri Matisse used gouache in simple, bold statements of blocks of colour, whereas other artists such as Valentin Serov used it in a more figurative and traditional way.

However, there are any number of styles of painting, and gouache will enable you to paint in a variety of ways to suit your own individual preference. For myself, the way I use gouache varies according to my mood! I sometimes like to use it rather like watercolour in a very fluid way, whereas at other times I choose to apply the paint much more thickly as one might work using acrylic paint. My own approach encompasses more styles than just these two I have mentioned. You too will discover and develop your own unique style of painting using gouache.

I have decided to introduce you to two other ways of painting in gouache that I enjoy working with, namely:

Poster style using flat areas of colour in a simplified way.

Illustrative style Gouache is also the perfect medium for illustrative work requiring intricate detail and patience.

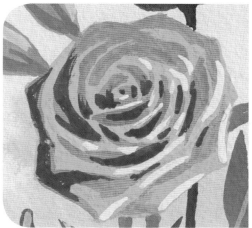

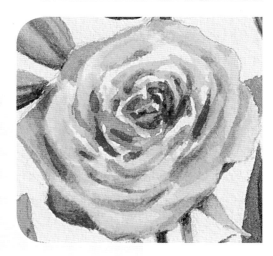

Roses in different styles

The topmost detail shows a rose painted using my own approach; with a variety of techniques. The poster-style version in the middle breaks the rose down into its basic shapes, colours and tones and is an interesting and challenging way of painting. The more realistic, illustrative approach at the bottom was produced by softening and blending colours and tones – even after they had dried – carefully using a damp brush.

Opposite:
Gouache is such a versatile medium that it lends itself to painting outside.

My preferred style

I tend to start working with watercolour-like techniques, then I might continue more thickly if I feel that the painting needs some stronger contrasts.

I painted *Garden Flowers* below in this particular style in order to capture the subject in a recognizable way, but without necessarily too much fuss and detail. It wouldn't be described as poster style or strictly illustrative, but it is my own style which is unique to me. Of course, if I had painted it differently, for example in a more fluid 'watercolour' style, it would still be unique to me because it is my own, original work.

Painting in your own, pure gouache style gives you the opportunity to experiment, to develop your own ways of working by playing with your paint and to find out what effects you can achieve. Your own, personal interpretation is unique to you and there is no right or wrong way to do this, but it gives you the opportunity to express yourself however you wish.

Garden Flowers

I drew the outline of the flowers with a B pencil and started painting them with yellows in a fluid, yet strong watercolour way, i.e. quite wet. I could have painted the darker background all over first, but painting the yellow over the top of the dark background would need several layers of yellow to make them bright enough. Alternatively, the background could be painted first around the flowers, leaving the flower shapes to be painted afterwards. The paint I used was quite thickly applied.

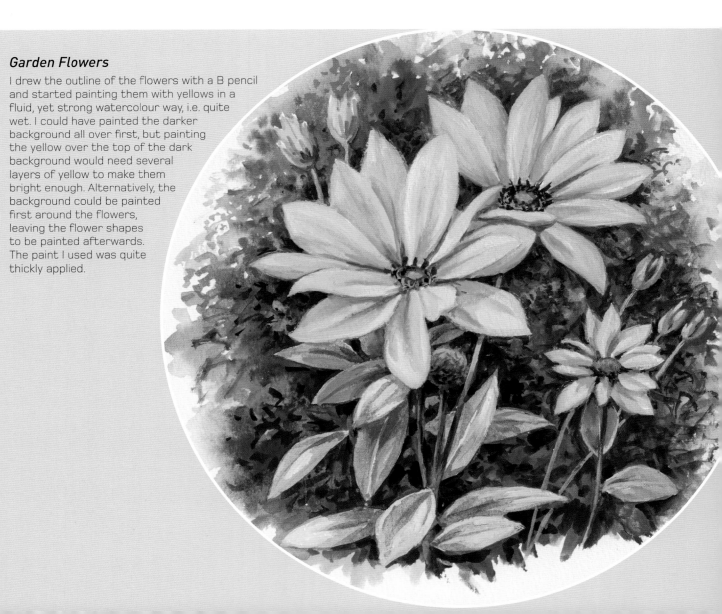

This is painted in a similar way to *Garden Flowers* opposite; it is a much looser style compared to the poster style and the illustrative style. I'd say there is a greater freedom of expression here, because I just go with the flow and see what happens! You will find the more you paint, the more your own distinctive style will emerge over time. You may notice the similarity of my style here in other paintings throughout the book.

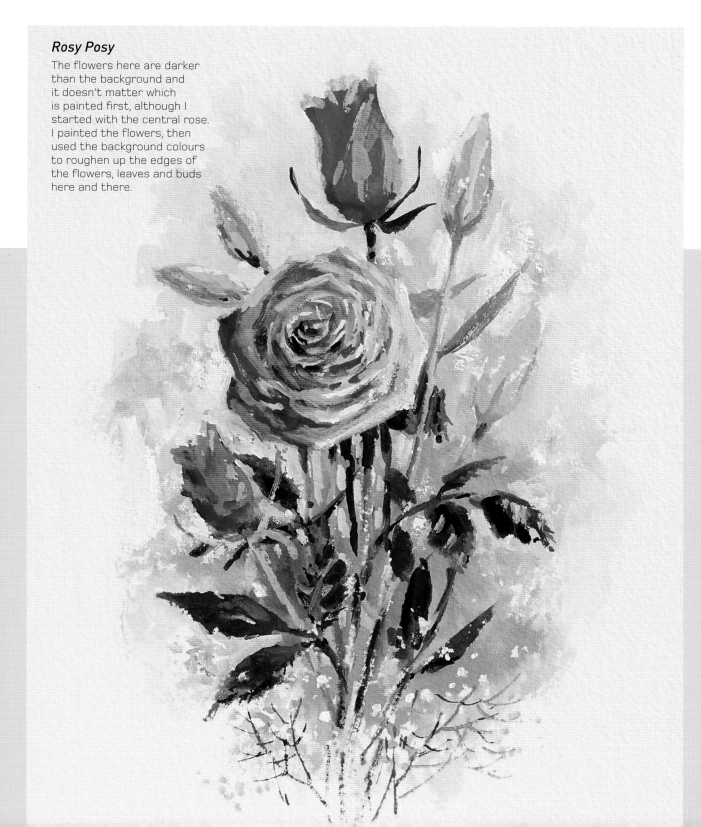

Rosy Posy

The flowers here are darker than the background and it doesn't matter which is painted first, although I started with the central rose. I painted the flowers, then used the background colours to roughen up the edges of the flowers, leaves and buds here and there.

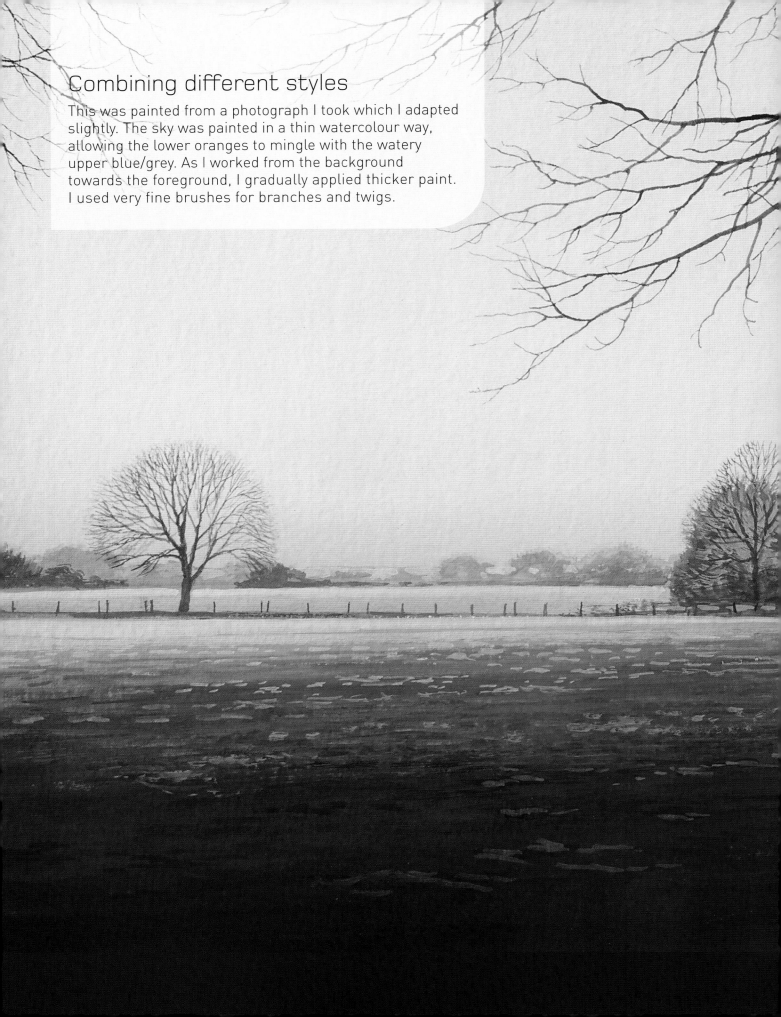

Combining different styles

This was painted from a photograph I took which I adapted slightly. The sky was painted in a thin watercolour way, allowing the lower oranges to mingle with the watery upper blue/grey. As I worked from the background towards the foreground, I gradually applied thicker paint. I used very fine brushes for branches and twigs.

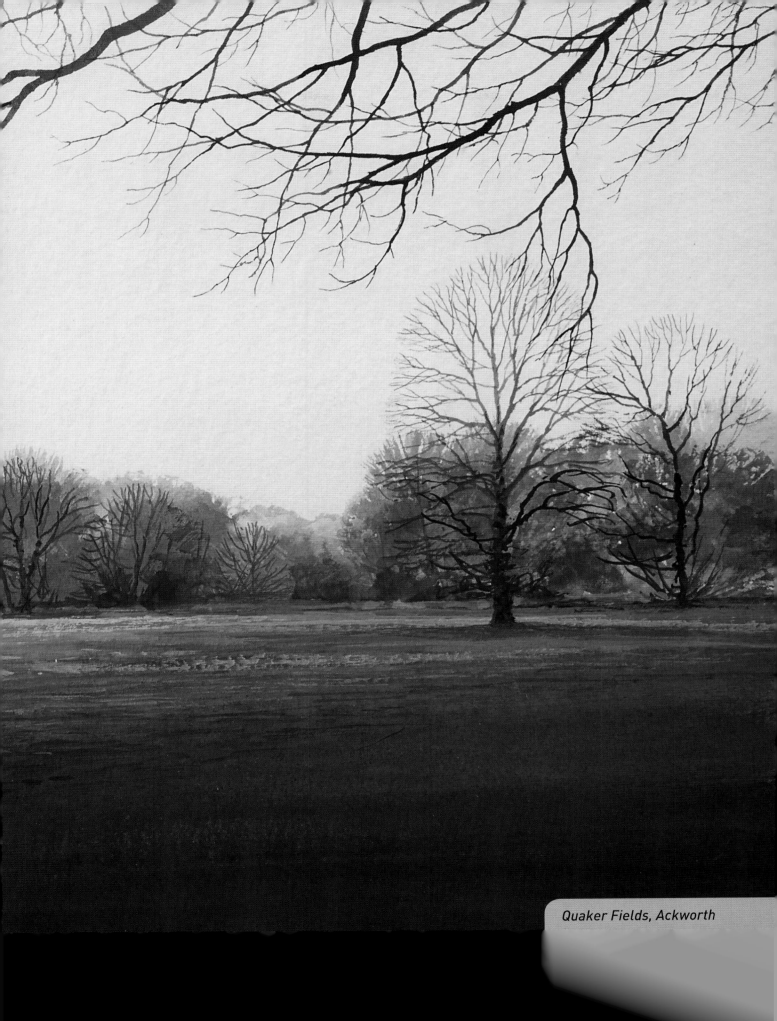

Quaker Fields, Ackworth

Developing your own style

Keep on painting! Just as you gradually develop your own handwriting style when you learn to write, so the more you paint in any medium, the more your own style will emerge and develop.

My 'unique gouache' style just means my own style, which will be different to your unique gouache style. This is changeable depending on my mood!

I have described how I paint, my methodology and what works for me, and hopefully you will find this helpful for your own work. I would encourage you to experiment and be prepared to make mistakes, which are learning opportunities and pathways to eventual success.

Key tip

Developing your own style takes time, and it's perfectly okay to take inspiration from others. When copying another's work, sign it with your name, then write 'after Jeremy Ford', or whoever the original artist is.

Bluebells at Nostell Priory

POSTER STYLE

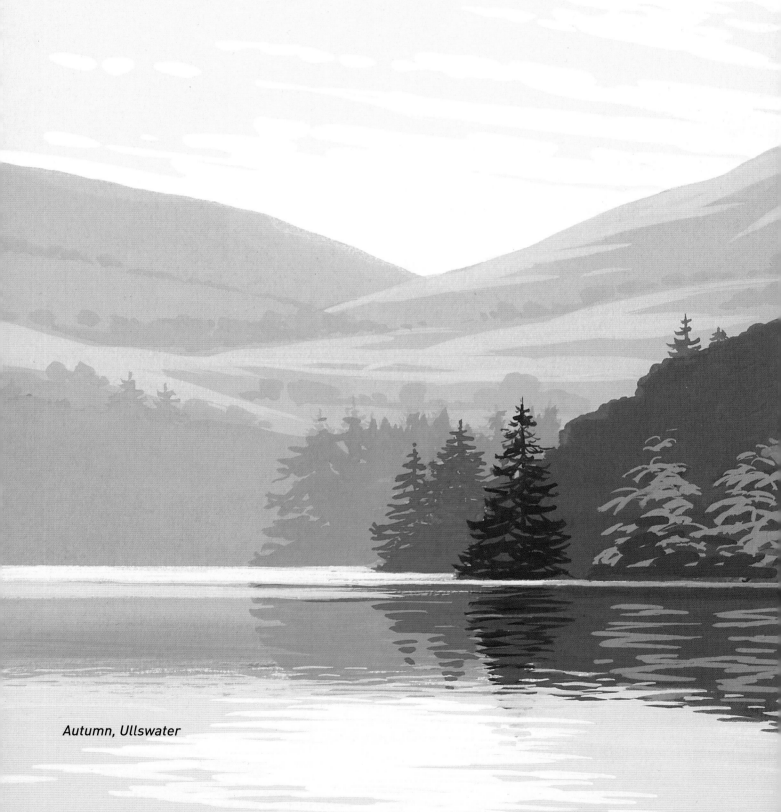

Autumn, Ullswater

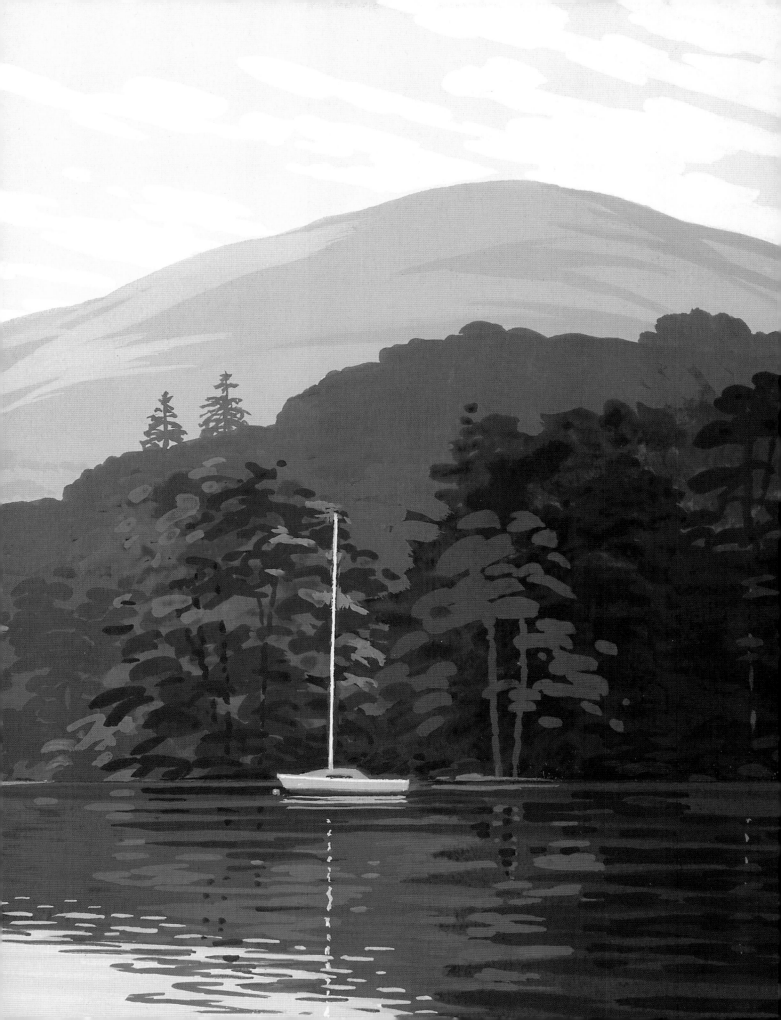

Introducing poster style

The poster style is a simplified depiction of a subject which usually involves little in the way of blending colours. Instead, it uses areas of solid colour, painted with a creamy consistency.

When each part of the picture has dried, layers are overpainted with other colours and tones if necessary, making sure each layer is dry before painting the next area of colour. Layering is perhaps the most distinctive feature of poster-style painting.

The poster style can be a very simple, effective and graphic way of painting, although attempting to depict the maximum effect with the minimum of suggestion is not always easy!

Opposite:
At Flatford Mill
I originally intended to paint some bullrushes in the foreground of this poster-style painting, but after painting the background I thought it would be a shame to cover it up with the bullrushes. I decided it was striking and simple enough without including them.

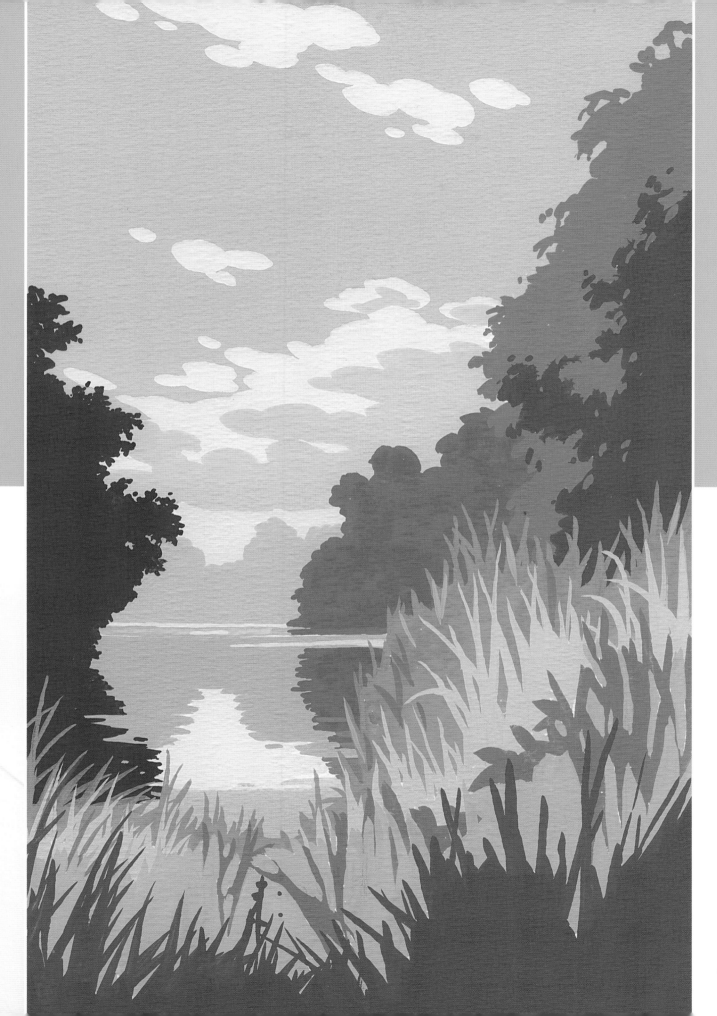

Poster style

You may be familiar with this style of painting from the poster art of the 1930s to 1950s. Or perhaps you may see a similarity with the artwork that has been traditionally painted on narrow boats or barges by the people who live and work on them.

To paint in a poster style requires little, if any, subtle blending of colours, just areas of hard-edged colour. It can be an interesting challenge to try and simplify a plant or a flower into flat tones and colours and make it look effective. If it doesn't work as well as you intend, you can always paint over it!

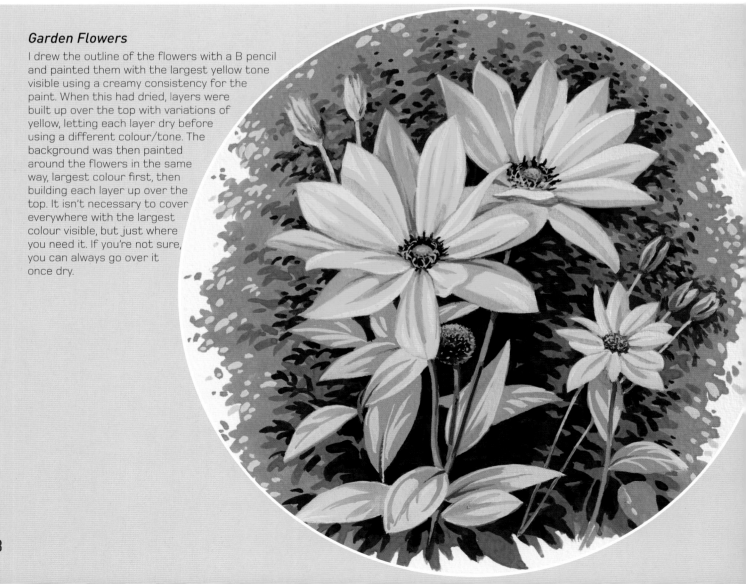

Garden Flowers

I drew the outline of the flowers with a B pencil and painted them with the largest yellow tone visible using a creamy consistency for the paint. When this had dried, layers were built up over the top with variations of yellow, letting each layer dry before using a different colour/tone. The background was then painted around the flowers in the same way, largest colour first, then building each layer up over the top. It isn't necessary to cover everywhere with the largest colour visible, but just where you need it. If you're not sure, you can always go over it once dry.

Rosy Posy

As this is a fairly simple image, I painted the background greys first then, when dry, applied the largest colour as a block in each area. When each part was dry, I added darker and lighter sections.

Project: *Ullswater Lake*

This is a painting of Ullswater in the Lake District, the second largest lake in England. It is an adaptation of a photograph I took some years ago (opposite) and the challenge was to break the photographic reference down into basic areas of tone and colour.

All paint mixes should be made to a creamy consistency for this project. This allows other colours to be painted on top. If the paint was watery, the overlaying wouldn't work.

You will need

- Watercolour paper or watercolour board (I am using a Line and Wash Board)
- B pencil
- Eraser
- Ruler
- Water dropper
- Kitchen paper
- Masking tape
- Spare watercolour paper for colour testing
- Paint: jet black, zinc white, cadmium yellow, burnt sienna, Prussian blue, permanent rose
- Round brushes: size 20, 10, 6, 4, 0

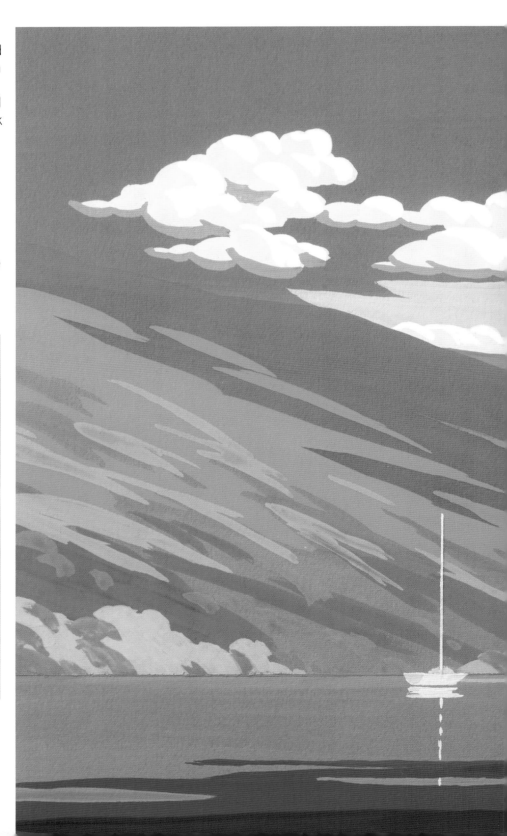

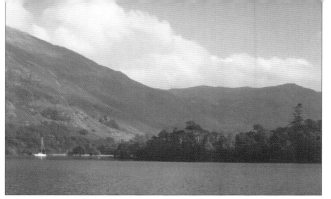
My original photograph.

The finished painting

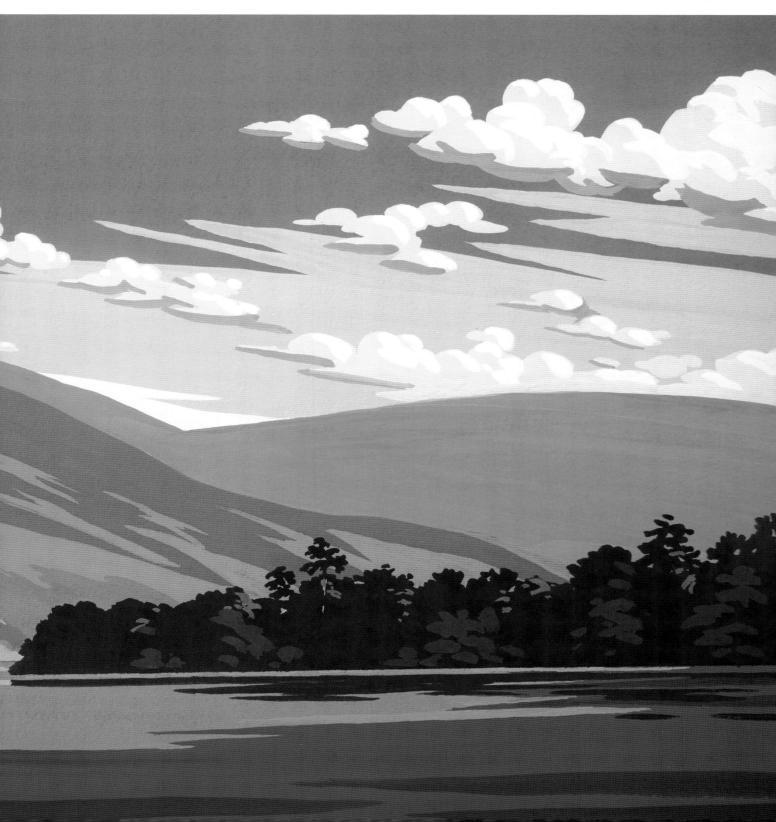

1 Tape or stretch your watercolour paper onto the drawing board (see page 56). Using a soft pencil like a B pencil, draw a simple outline of the painting: sky, land and water. The clouds and boat can be painted on top at a later stage. Use a ruler to create a straight line at the water's edge. Draw faintly, not pressing too hard, otherwise the pencil lines might show through the paint at the end.

Key tip

When the paint is wet or damp it can look streaky, but it should dry more evenly. If the finish is not as smooth as you would like, you can paint over it again, once dry.

2 Squeeze some Prussian blue and zinc white into two wells of a palette. Fill another well with a few drops of water.

3 Using your size 10 brush, take a blob of white paint (about the amount you might put on a small toothbrush) and add it to the well with the water in. Stir it in to make a creamy milk consistency. Mix plenty of paint – it's better to have too much, rather than not enough.

4 Wash the brush, then add Prussian blue to the white in small quantities to get the strength you want for the sky colour. Mix thoroughly. Check the colour on a piece of spare paper, as the colour will dry much darker than it looks when wet.

5 Using a size 20 brush, apply the paint generously on dry paper to the upper part of the sky. Apply as evenly and smoothly as possible, using horizontal strokes. Don't leave any gaps at the edge of the paper. It doesn't matter if you paint over the edge of the tape. Paint down as far as the top of the hills on the left. If the finish isn't as even as you would have liked, you can paint clouds over the streaky bits!

6 Make a paler blue for the rest of the sky, of the same creamy consistency. Squeeze zinc white out into a well. Take a small amount of Prussian blue and mix thoroughly with the white. As before, test the colour on spare paper, on top of the previous paint, to check it is thick enough to cover up the darker paint.

7 Using your size 10 brush, apply the paint to the lower part of the sky, using the paint generously and painting on a slight angle over the top of the existing paint. If, when dry, the darker colour is still visible through the paler coat, apply a second coat of the paler mix. Paint this down to the top of the fells. Don't worry if you paint over any pencil lines. Keep your mixes, as it is hard to mix exactly the same colour again and you may need to touch up any imperfections later.

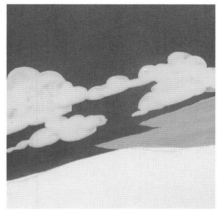

8 Mix a cream for the cloud colours. Squeeze zinc white and a small amount of cadmium yellow into separate wells. Start with the zinc white and add small amounts of cadmium yellow to it until you have a buttery colour. Make it a milky/creamy consistency, thick enough to cover up the existing blue paint. Test the colour on the practice paper, on top of the blues.

9 Using a size 6 brush, paint clouds where you like, using the paint thickly but applying it lightly. Try not to disturb the surface of the blue, otherwise the blue paint will loosen. If that happens, stop, dry it with a hairdryer and reapply it. Any parts of the sky you are not happy with you can paint a cloud over. Paint clouds with tops and sides rounded and the underside flatter.

10 Try to avoid making all your cloud shapes the same. Don't worry if the coverage isn't too even at this stage, as there is still white to apply, as well as shadows.

Key tip

Start with the upper clouds and work your way downwards so you don't smudge them with your hand.

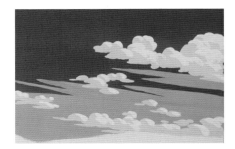

11 Add a creamy consistency of neat zinc white to the edges of the clouds where the sun would hit them.

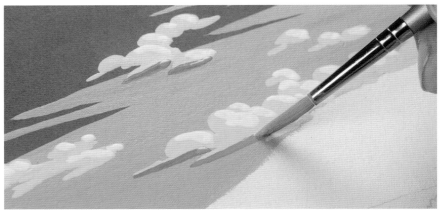

12 Mix a shadow colour using Prussian blue, a small amount of permanent rose and zinc white, to give a purple/violet mix of a creamy consistency. Apply to the bottom part of some of the clouds.

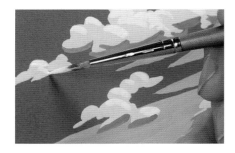

13 Retouch any shadows, or add an extra cloud if you feel it needs it. To create more of a distance in the sky, add some zinc white to the base of the sky. Allow to dry.

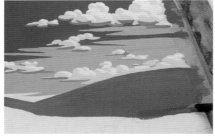

14 Paint the background hills on the right side of the painting, using a size 10 brush. Use the colour you used for your shadows, but with a tiny amount of burnt sienna added and follow along the pencil lines you have drawn.

15 Make a dark purple using Prussian blue and permanent rose with a touch of both zinc white and burnt sienna, to give a creamy consistency.

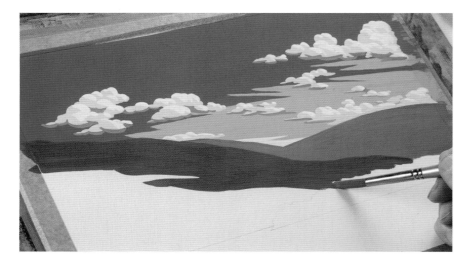

16 Apply this new mix to the upper part of the nearer hills in the direction of the hillside.

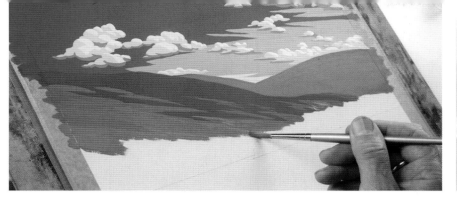

17 Squeeze burnt sienna into a well and mix with cadmium yellow and a touch of zinc white to make an orangey brown. Using a size 6 brush, paint in patches over the lower part of the hills, in the direction of the hills. Take the paint about halfway down.

18 Make a mid-green by mixing Prussian blue and cadium yellow with a bit of the orangey brown mix.

 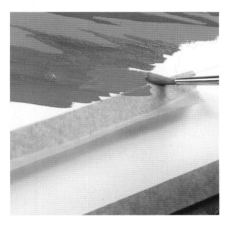 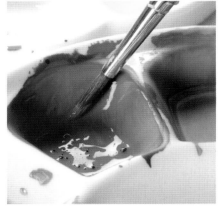

19 Put some masking tape in a horizontal strip over the water's edge on the left-hand side, adhering the top half to the paper, but leaving the bottom half unstuck.

20 Using a size 6 brush, apply the mid-green over some of the orangey brown, painting down as far as the tape.

21 Make a mid/dark green by mixing burnt sienna with a little Prussian blue, and adding some cadmium yellow and a small amount of zinc white.

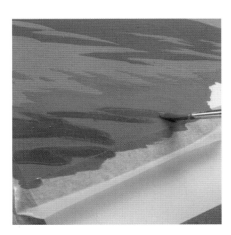 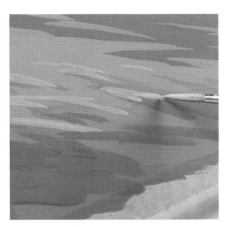

22 Using a size 6 brush, apply some of this over the previous green, in the direction of the hills.

23 Mix a grey using zinc white, Prussian blue, a small amount of permanent rose and a tiny bit of burnt sienna to make a creamy consistency. (If you prefer, use jet black and zinc white to mix a grey.)

24 With your size 6 brush, apply the grey among the greens and browns in small, linear shapes.

25 Mix cadmium yellow with a little zinc white and a touch of permanent rose.

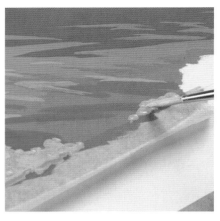

26 With a size 6 brush, apply to create small trees and bushes at the water's edge.

27 Make a yellowish green by adding some of your mid-green mix to the yellow mix.

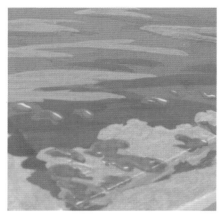

28 Using your size 6 brush, create small shadows on those yellow trees and in the background.

29 Once the paint has dried, carefully lift the tape off.

30 Apply a strip of tape where the previous piece was, leaving a 1mm amount of paint showing below the tape.

31 Add a second strip of tape to continue the horizontal line, but stick it slightly lower down to create the dark tree line. Change to a size 10 brush.

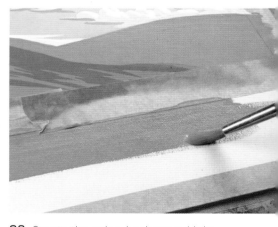

32 Create the paler, background lake colour by mixing Prussian blue with zinc white. This should be similar to the sky colour, but slightly paler. Apply in the upper part marked out by the tape, covering the tape.

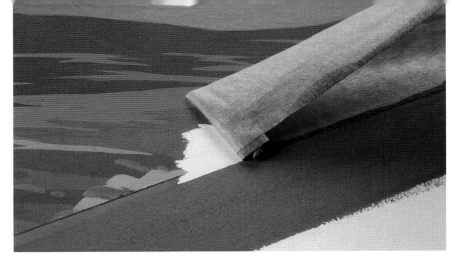

33 Allow to dry, then remove the tape carefully and slowly. The tape shouldn't take off any of the paint, but if it does you can reapply the paint from the colours you have already mixed.

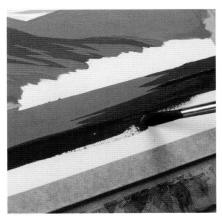

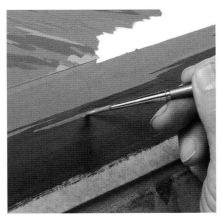

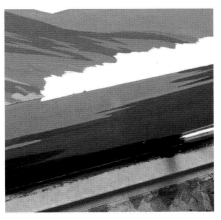

34 Still with your size 10 brush, create the darker, foreground lake colour by mixing Prussian blue with a very small amount of zinc white. Apply on the top right and all the way down to the bottom, using horizontal brushstrokes, over the top of some of the existing blue.

35 Using a size 4 brush and your first lake colour, add a few isolated patches to create the impression of movement on the water.

36 Make a darker lake colour for overlaying on the foreground, by adding more Prussian blue to your second lake mix here and there. Add to create contrast and a sense of gentle movement on the water.

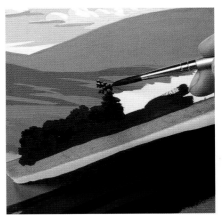

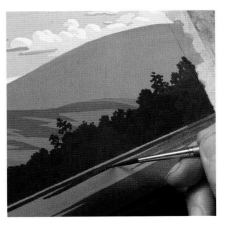

37 To paint the trees, mix Prussian blue and burnt sienna to give a very dark green: an almost black green. Add a strip of masking tape at the top of the water, leaving 1mm of the water visible at the top.

38 Using the tip of your size 4 brush, paint very dark green over the remaining area, defining some tree shapes. Allow to dry, then remove the tape slowly. If any colour has crept underneath the tape, you can touch it up.

39 Using the same colour and brush, paint horizontal lines under the trees on the surface of the water, to give the impression of broken reflections of the trees above.

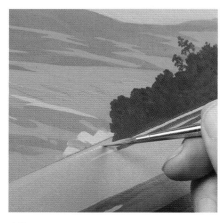

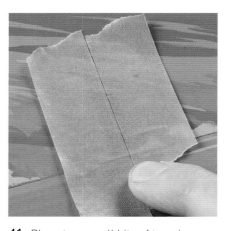

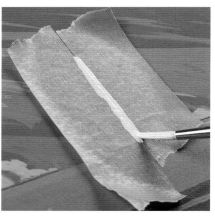

40 Using cadmium yellow with a little bit of zinc white, do the same under the yellow trees to create reflections in the water. Allow to dry.

41 Place two small bits of tape in parallel vertically to mark out the area where the mast of the boat will be (about 1mm in thickness). Rub both pieces in the middle with your fingernail to ensure that they are flat and no paint can creep underneath the tape.

42 Using zinc white with a touch of your buttery mix, paint a vertical strip starting about 4cm (1½in) above the top of the lake and finishing at the top of the lake.

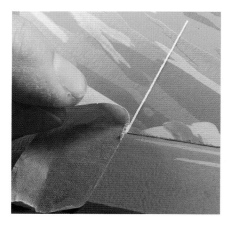

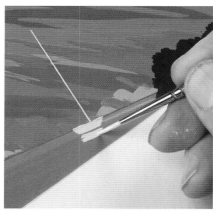

43 Allow to dry, then carefully peel off the tape one strip at a time, to reveal the mast of the boat.

44 To create the boat, change to a size 0 brush and, using the same colour, paint a horizontal line with a slight curve, just above the water's edge. Continue to fill in the rest of the boat shape then proceed to paint the reflection of the boat, leaving a very tiny gap between the boat and its reflection. Use broken, horizontal strokes.

45 Add the reflection of the mast, ensuring it is directly underneath the mast. You can use the side of a clean piece of paper to help you align the mast and its reflection.

Key tip

When working on top of the water, if your hands are clammy they can disturb the paint underneath. Use a piece of spare paper to rest your hand on.

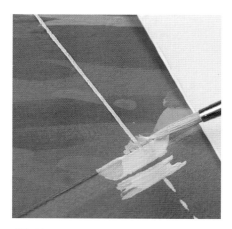

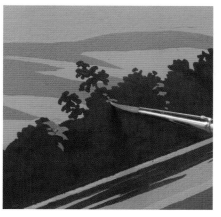

46 Using zinc white with a tiny amount of Prussian blue, paint the cabin, the stern and its reflection.

47 For the finishing touches, use your yellowish green here and there on the dark trees to suggest little bits of light.

48 Add a tiny amount of cadmium yellow to the very dark green to make it slightly paler. Add touches of this in small amounts in the foliage to break up the solid block of colour.

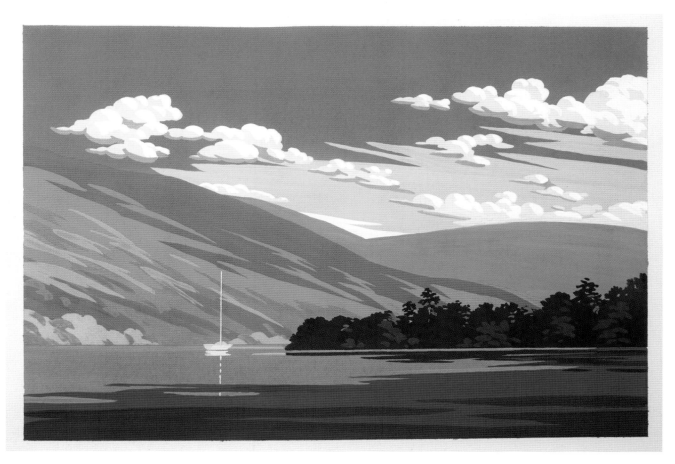

49 Allow to dry and peel off the tape carefully from each edge to reveal the finished painting. You can see the finished painting on pages 80–81.

Cober Hill

This painting is similar in subject matter to *Ullswater Lake*, but in this painting the clouds are just white without any shadows or highlights. Clouds vary so much in different weather conditions. There is a little subtle blending of different tones in the sea which can be done wet or dry. In the green field there is wet blending, lighter at the top, darker lower down.

The overall effect is heightened by the clean poster styling with its solid colours, tones and sharp edges. The result is a bright, cheerful painting that encapsulates warm sunny days in the countryside.

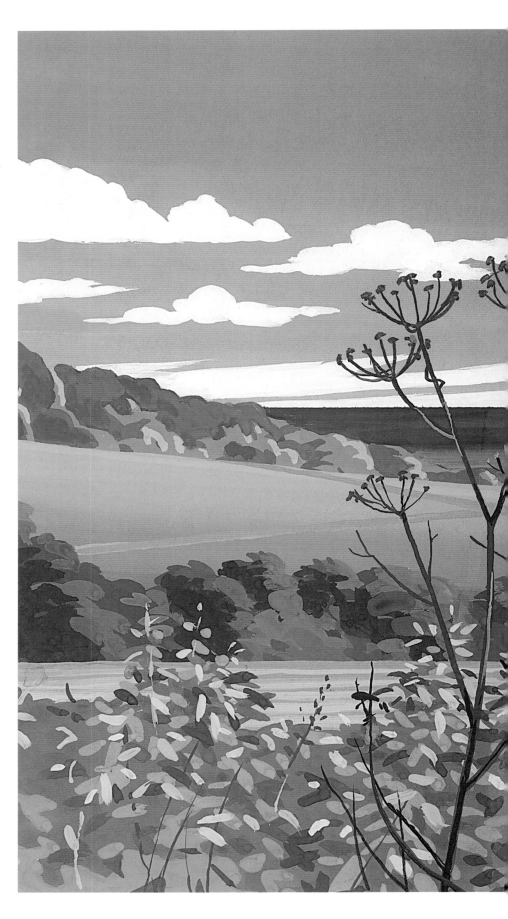

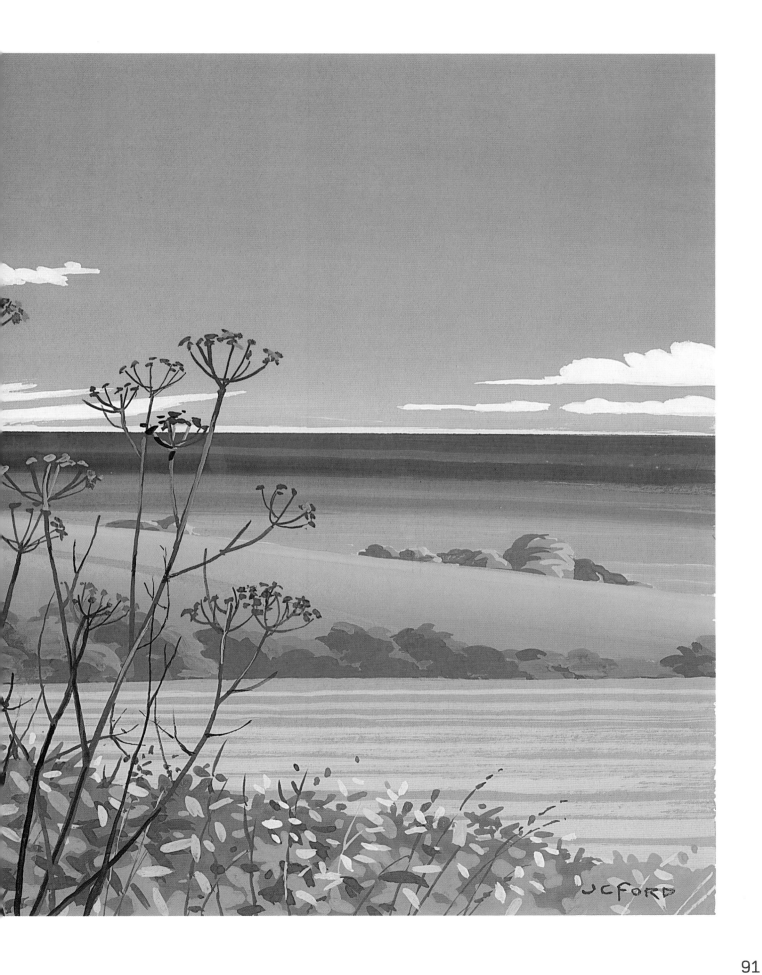

Lake Calm

I drew the basic composition with a
B pencil, using a ruler for the water's
edge. Next, I applied a creamy wash of
blue mixed with plenty of white to the
sky, as far down as the hills. While this
was drying, I painted the lake down to
the bottom of the picture with the
same colour, using masking tape over
the bottom edge of the land above
the water, to separate the hills from
the lake.

I then painted each section in
turn from the background to the
foreground, making sure each area was
dry before applying the next colour
layer. To get the slightly broken effect
of the light grey reflections lower
down, I only partially loaded my brush
with paint so it would gradually run out
of colour as I dragged it across. (If you
haven't tried this technique before,
practise on a piece of paper first.)

For the very straight lines, I used
masking tape as in the *Lake Ullswater*
project (see pages 85–87), letting the
paint dry before slowly and carefully
removing the tape.

Finally, the reeds were painted over
the lake colour, from furthest away
towards the immediate front right.

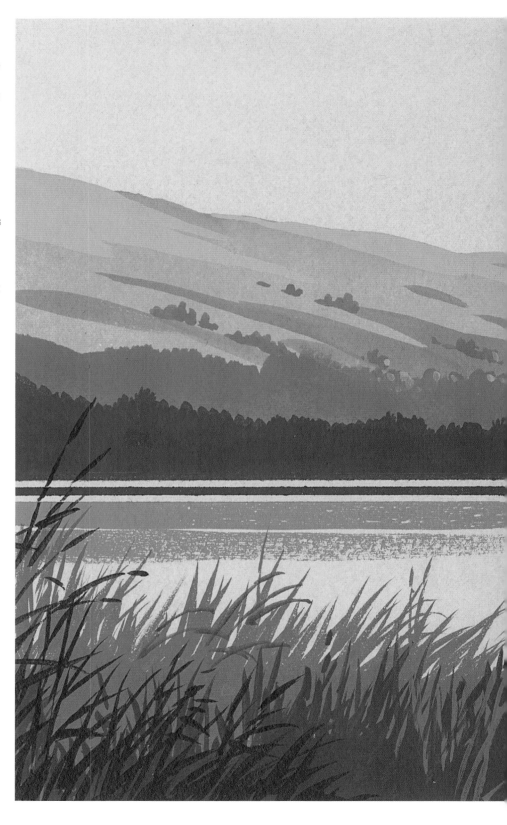

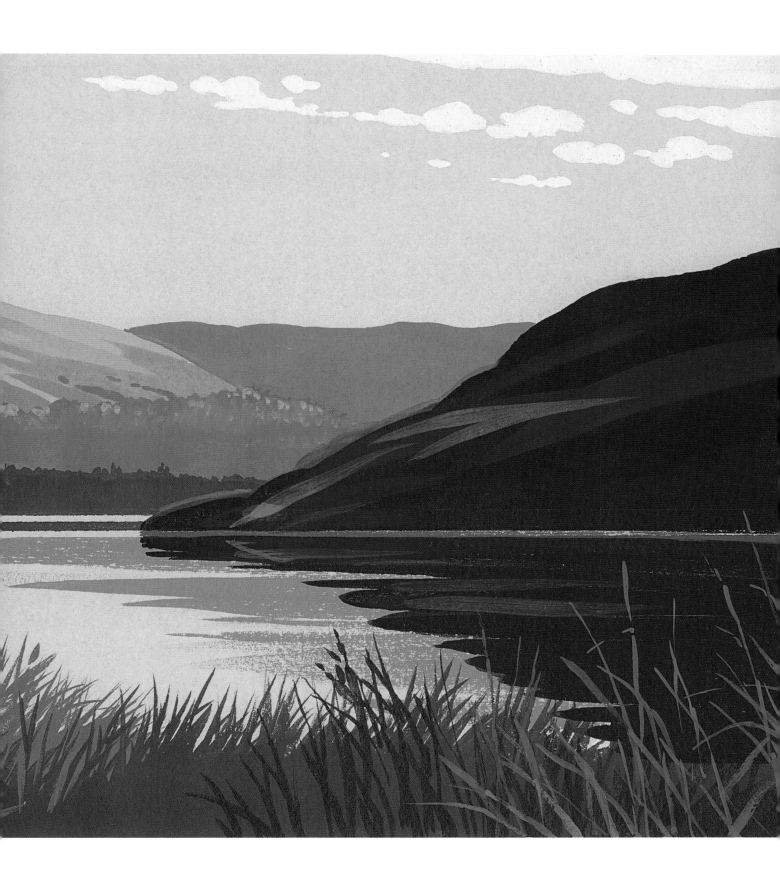

ILLUSTRATIVE

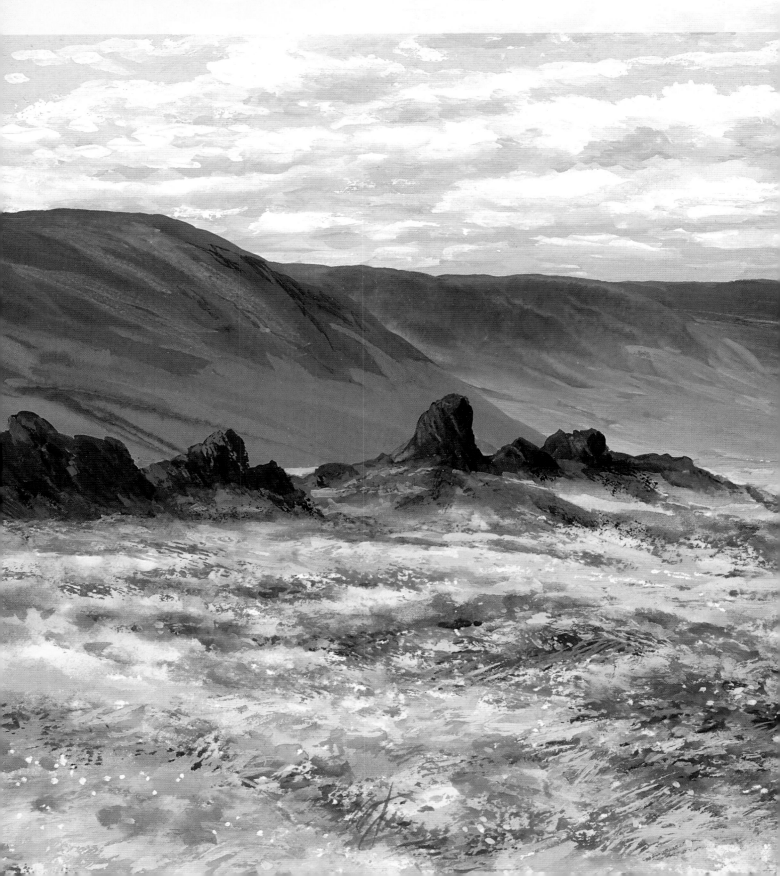

STYLE

Þingeyjarsveit, Iceland

Introducing illustrative style

Gouache has traditionally been a popular medium for professional illustrators and botanical painters because of its versatile and precise qualities. As seen, you can rework or improve areas very easily with this opaque medium, which lends itself to more accurate or detailed work.

Although gouache can be used in looser, more expressive styles – as shown elsewhere in the book – this more detailed approach is a great strength of the medium; and it can be used to make illustrative paintings more easily than looser media like pastels or watercolours; and more swiftly than with oils. If I wish to paint in an illustrative style, I almost always use gouache because of this.

When a viewer says a painting looks 'just like a photograph', it is almost always meant as a compliment – photorealistic work, after all, is technically impressive; but it is not as difficult as you may think: everything is placed in the photograph for the artist to copy. While great care, skill and patience are still required to paint a successful photorealistic artwork, there is no need to compose or space to interpret, which can feel a bit restrictive. I think that what is really difficult – and thus more rewarding – is translating a photograph into an interpretation which is uniquely yours.

When using the word 'illustrative' to describe this style, then, I mean working in a way that attempts a certain amount of photographic realism, but that also allows some space for artistic choice and exploration. For example, I might use a lot of detail in one area, but not necessarily all over the painting. This can be useful for drawing attention to a particular spot when other areas are less important to the composition. This part of the book looks at this synthesis between precision and expression.

Opposite:
Orange Lilies
As this is a more illustrative style than the poster style discussed earlier in the book, greater care was taken with the accuracy to depict the main flower and stems.
The background is less important, so it is more loose in style. The flower was drawn first, then the background painted around the flower shape. When dry, the flower was painted and the stems were painted over the dark, contrasting background.

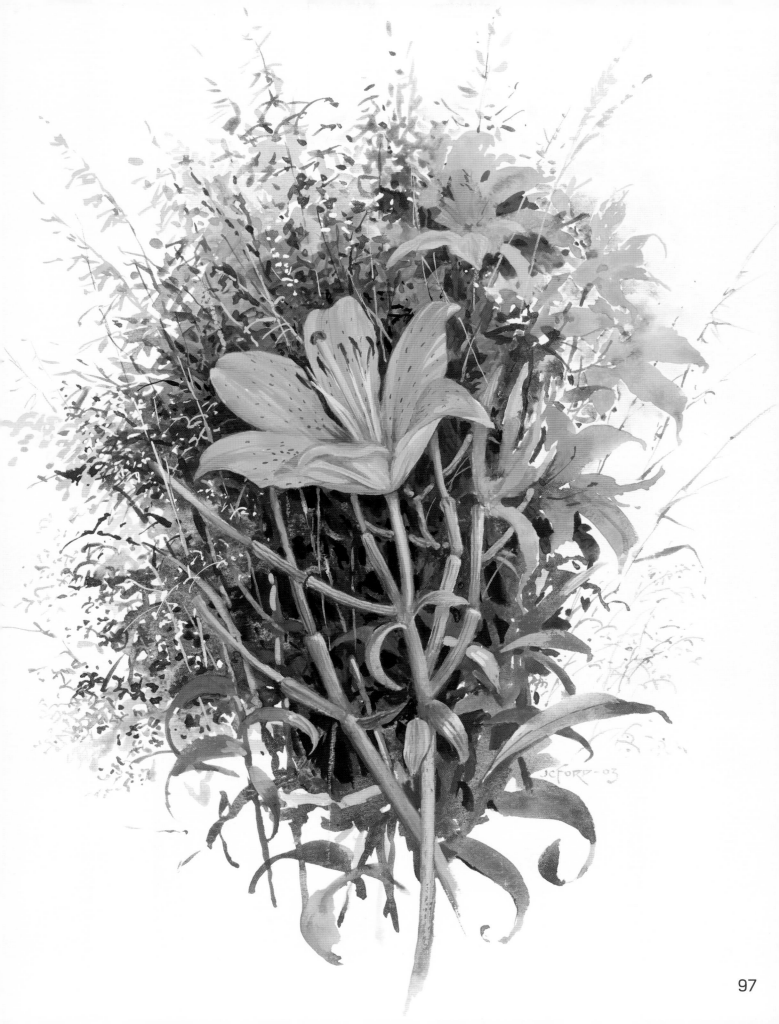

Illustrative style

Gouache has traditionally been used by many illustrators over the years and botanical illustration works well in gouache. This kind of subject which requires careful painting and accurate detail can be achieved with care and continual practice. The precise approach of this style provides more visual information about the subject because of the close attention to detail.

Watercolour is frequently used by botanical artists and illustrators, but it may be easier to use gouache, because watercolour needs to remain fresh and transparent looking and if it is overworked it becomes dull. Gouache lets the artist repaint over any mistakes.

Garden Flowers

The flowers were drawn using a B pencil and the background painted around the drawn flowers. I could have painted the flowers first, but the sequence doesn't really matter because mistakes can be painted over when dry.

The background is not done in an illustrative style as it is only needed to make the flowers stand out. I could have left out a background, but I think the dark background creates a nice strong contrast to the pale flowers.

Some subjects in an illustrative style don't have a background at all because it's not considered important and the subject itself has sufficient visual information.

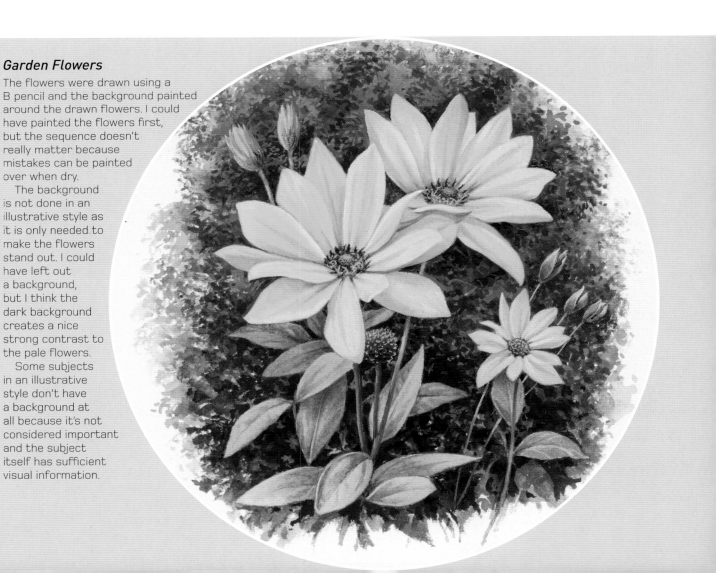

Rosy Posy

With the flowers, leaves and buds being quite deep in colour, I decided that a background was unnecessary. I started with the central rose, working light to dark, then gradually built the arrangement around it.

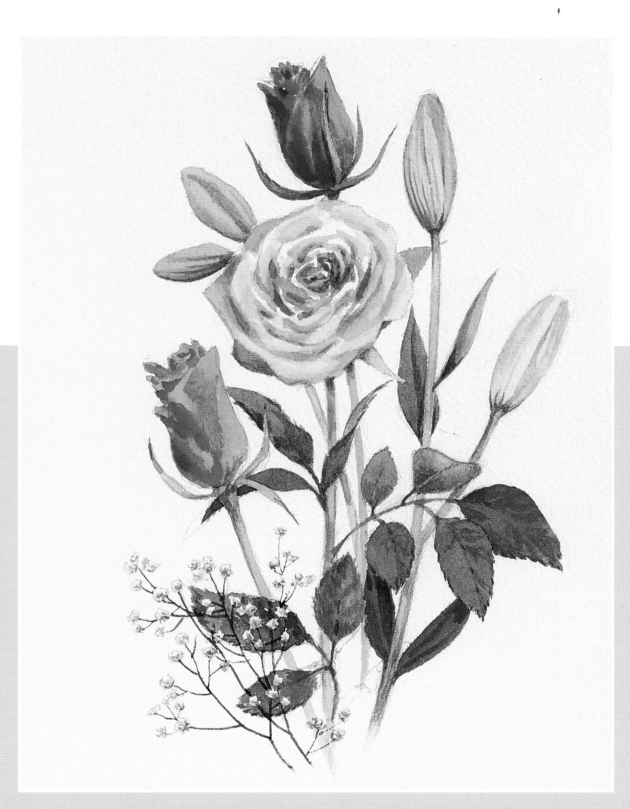

Working from life

In this example, I picked some ivy which was growing nearby for this study, but you can use anything small enough to place on the paper on the drawing board in front of you. To start with, choose something simple and uncomplicated before moving on to more complex subjects. The ivy I am colour matching below is not the same piece of ivy you can see opposite in *Garden Ivy*. You will see, in particular, that the greens are different.

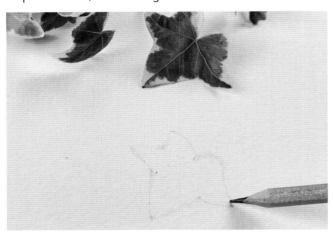

1 Copy the size and shape of one ivy leaf, drawing a vague outline using a 2B pencil; I'm hardly touching the paper.

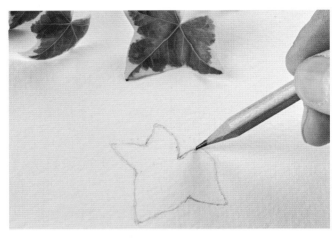

2 When you're happy with the size and shape, draw more definite lines.

3 Put a small amount of water in an empty well and dip your brush in it. Add a small amount of cadmium yellow to make a milky mix. Wash the brush and add zinc white to the mix. Add a fraction of ultramarine and a larger amount of lemon yellow. Wet mixes in the palette can look very different to the finished dry colour on the paper, so test your colour on a spare piece of paper and hold it up against your object to check the colour. If the colour doesn't quite match, keep adding small amounts of the colours in your palette.

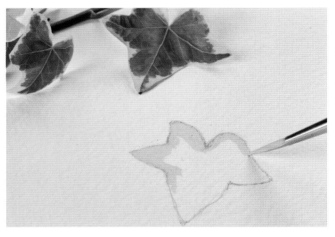

4 When you're happy that the colour of the leaf matches the colour on the paper (not the colour in the well), you can start to paint the object in front of you.

Key tip

When drawing from life, I keep my drawing lines very light and easy to rub out. I draw a faint line and when I'm sure about it, I make it more definite.

Garden Ivy

It is always a good exercise in observation to find an object and copy it, particularly objects from nature. There is an abundance of material to choose from and it doesn't have to be pretty, or make a picture. Leaves, stones or bits of wood can be very useful to help you improve your observational painting.

Project: *Red Onion Still Life*

As you will be colour matching the onion in front of you, you should only use my colour mixes as a guide. You might find that you arrive at the colour you want in a slightly different way, and that's okay. The colours I have chosen are for this particular project, but your onion will look different to mine. You may or may not want to keep the loose flap of skin. You may want to peel the skin off altogether to reveal the flesh underneath. You might choose to paint an onion that is sprouting so that you can paint the vibrant green shoots.

You will need

- Red onion, mine has loose skin
- Line and Wash Board, Hot pressed
- 2B pencil
- Eraser
- Paint: jet black, burnt sienna, zinc white, Winsor green, permanent rose, cadmium red (or vermilion), cadmium yellow, ultramarine
- Round brushes: size 6, 1, 0

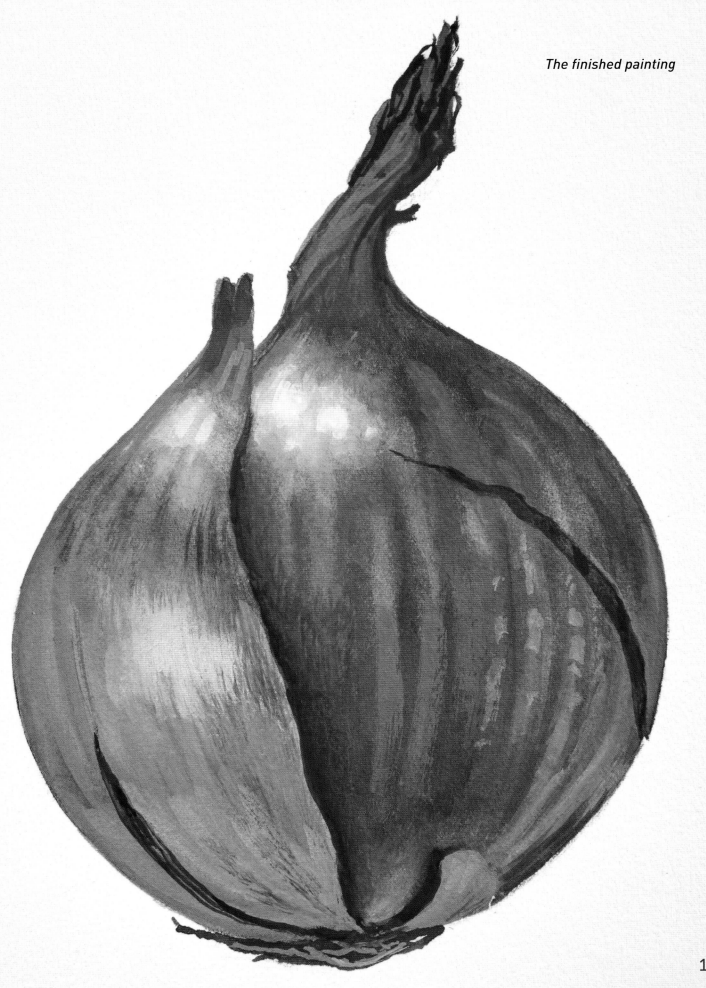

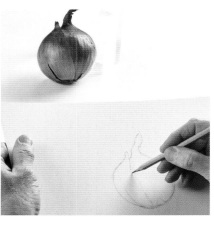

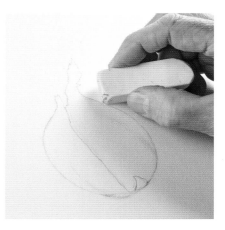

1 Turn your board to a landscape orientation. With the onion propped up in front of you, start in the middle of the paper and with the side of the pencil draw a vague outline, pressing lightly.

2 When you are happy with the specific shape, you can make more definite marks, pressing more heavily with the pencil. Don't worry about being too accurate, as long as what you end up with looks like an onion.

3 Remove any extraneous lines carefully with an eraser.

Key tip

Tilt the board towards you and hold it with one hand, or rest the top so it is slightly elevated. If you work on a board that is completely flat, you may end up distorting the perspective.

4 Squeeze out the following basic onion colours into separate wells and add water to make them a watery consistency: cadmium red, ultramarine, Winsor green, zinc white, burnt sienna, permanent rose and cadmium yellow. Mix together permanent rose with a little burnt sienna, to make a deep red of a milky consistency. Make a second mix of permanent rose with a small amount of Winsor green. This will give you an aubergine colour of a milky consistency. Make a third mix of burnt sienna with some ultramarine to darken it, then add some zinc white to the milky mix. This will give you a greyish brown. Make a fourth milky mix of ultramarine with a touch of burnt sienna until it becomes a dark grey.

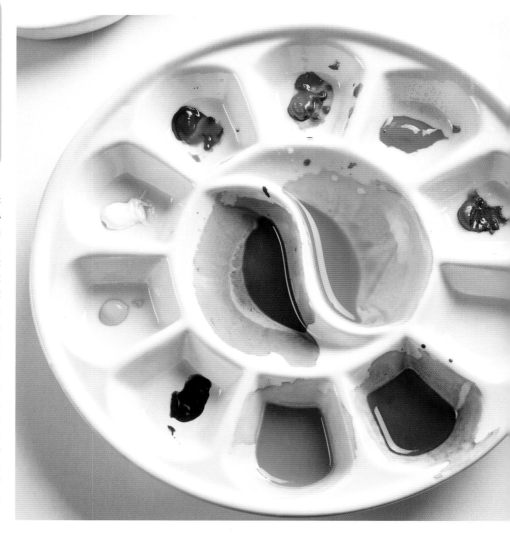

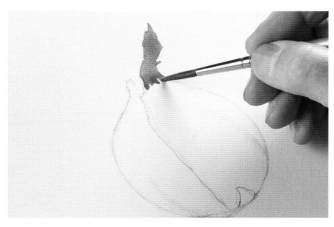

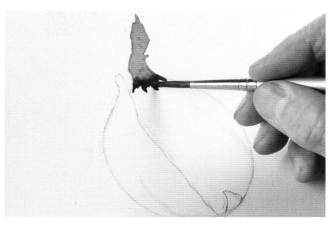

5 Using a size 6 brush, add your first mix of deep red to dry paper, starting at the top of the onion and working down towards the neck.

6 Now add the aubergine mix below the first mix, allowing the colours to merge.

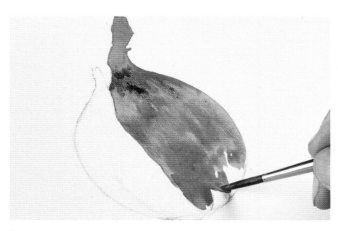

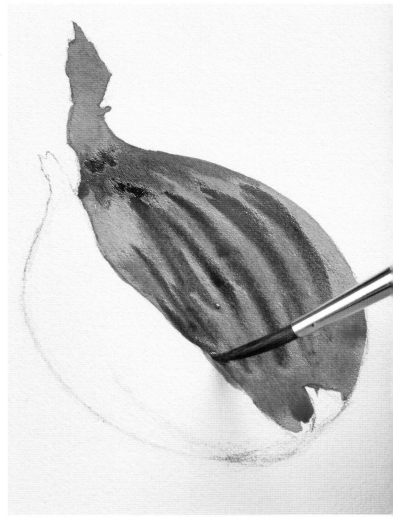

7 Add your deep red mix below the aubergine mix, painting all the way down to the bottom of the onion. We are working on the right-hand side of the onion only.

8 Using the aubergine mix, add some strokes in downward curves, following the curves of the onion.

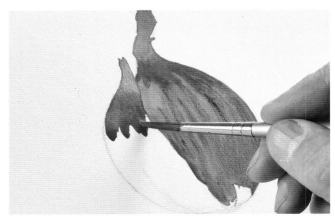

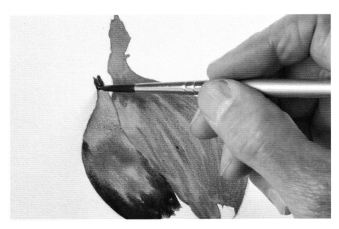

9 Moving to the left-hand side of the onion, use your greyish brown mix to paint from the top down to the neck. Add the deep red mix below, letting it melt into the colour above.

10 Using your aubergine mix, paint the left edge of the onion, adding a bit to the very top left-hand part of the onion.

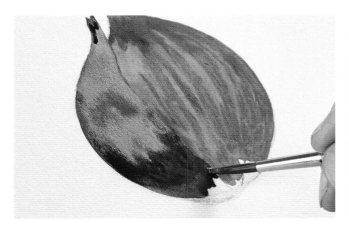

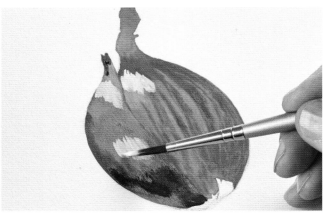

11 Taking the greyish brown, fill in the remainder of the left-hand side, leaving the base of the onion unpainted.

12 Add a touch of zinc white (don't make it too watery) to areas at the top and middle, where you want to show highlights.

13 Using the greyish brown, add curved strokes following the shape of the onion over the top of the background colour.

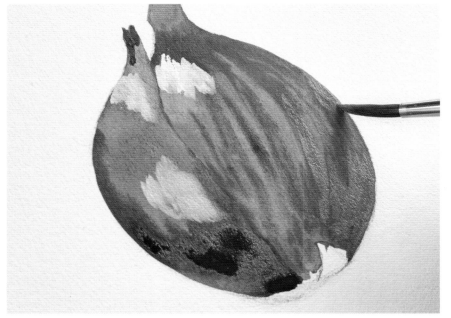

Key tip

Don't worry too much if the colours aren't exact at this stage – we are building it up in layers (like an onion!).

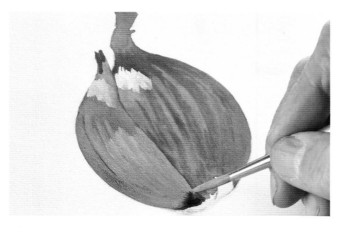

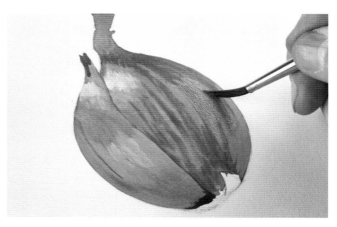

14 Take a brushful of the greyish brown and add zinc white to it and a tiny amount of cadmium yellow. Paint this on top of the background colour on the left-hand side of the onion, almost down to the bottom, following the contours of the object. This has the effect of dulling down the colours. Repeat on the right-hand side and allow to dry.

15 Still using the size 6 brush, soften any hard edges on both sides with a damp brush in the same direction as before.

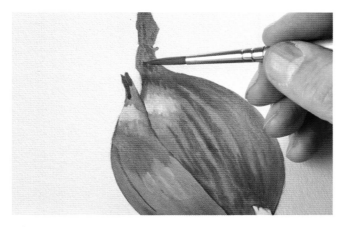

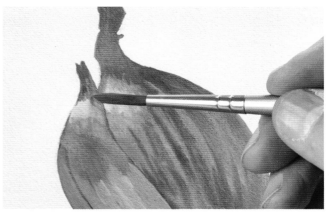

16 With a small amount of weak burnt sienna, paint over the top part of the onion down to the neck. I did this because the top of mine looked too red. If yours looks the correct brown, you can miss out this step. The beauty of gouache is that you can add more colour on top, so you don't need to get it right first time!

17 Add some of the same burnt sienna to the top of the left-hand side of the onion (where the flap of loose skin is).

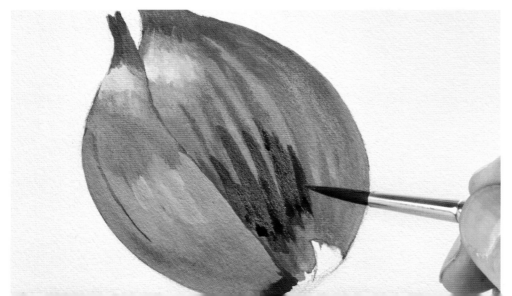

18 Using a weak aubergine mix and a damp (not wet) brush, go over the lower part of the onion from the middle downwards, in the direction of the contours. Be careful not to make all the strips identical in width; it creates more interest to add variation.

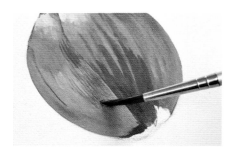 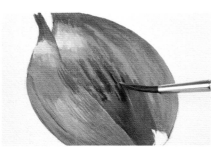 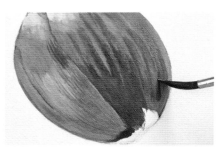

19 Using a slightly diluted version of the same colour, but an almost dry brush, add a light touch to parts of the left-hand side.

20 Go over the upper centre of the onion with a damp brush of diluted greyish brown, not too wet, using the same downward strokes.

21 Using the weak aubergine mix and a damp brush, go over the right-hand side of the onion.

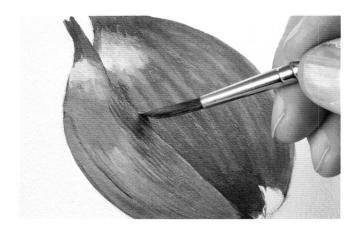

22 Add a little zinc white and a little cadmium red to some permanent rose. Paint this over areas of the centre which may be too bright.

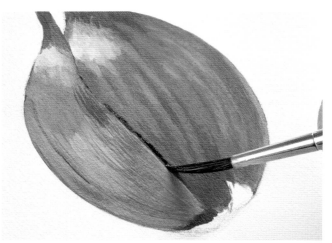

23 Add a tiny amount of Winsor green to the original aubergine mix, along with a small amount of cadmium red, resulting in an almost black mix. Paint this to the right of the loose skin on the left of the onion and the lower right – this forms the shadow that is cast by the onion skin.

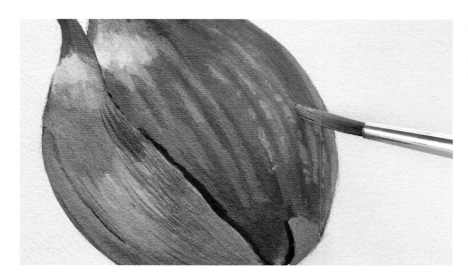

24 Taking the greyish brown mix, fill in the unpainted bit at the bottom and add a few irregular strokes to the right of the onion, here and there.

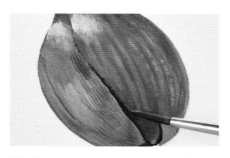

25 If any strokes anywhere on the onion are too severe, soften with a damp brush. Also soften the hard edge to the right of the shadow in the same way.

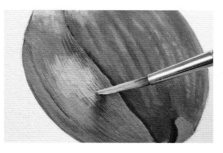

26 With a damp brush and some zinc white mixed with a tiny amount of cadmium yellow (to make an ivory colour), add some highlights to the middle of the left skin.

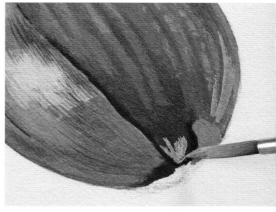

27 Repeat with zinc white and a small amount of permanent rose on a damp brush in the bottom-right of the onion and in the bottom centre. Soften any unwanted hard edges with a damp brush.

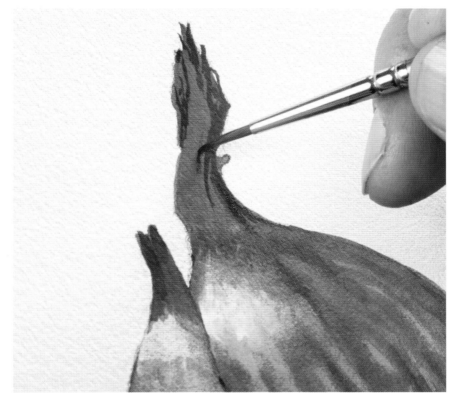

28 Paint the shadowy folds at the top part of the onion with the aubergine mix (with Winsor green added), using a damp size 0 brush.

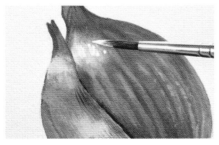

29 With your size 6 brush, increase the strength of the reflection at the top centre, by adding some more zinc white. Allow to dry and then soften with a damp brush.

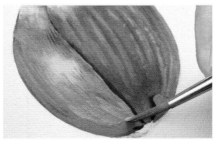

30 Keep an eye on colour matching the object. Mine needs lightening, so I add some zinc white to the deep red mix and paint over the top of the first layer of greyish brown on the left-hand side, to provide contrast between the onion skin and the onion.

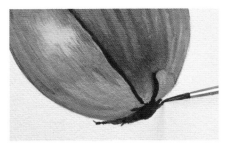

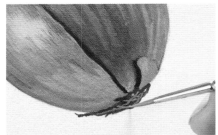

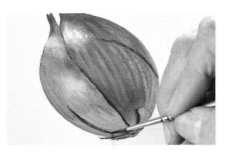

31 Make a new mix of ultramarine and burnt sienna to give a dark brown. Using a size 1 brush, paint in the roots. Allow to dry.

32 Take a small brushful of this new mix and add a tiny amount of cadmium yellow and a good amount of zinc white to give a sandy colour. Using the tip of your size 0 brush, paint on top of the roots.

33 Add the splits in the skin using the original aubergine mix and a size 0 brush. Allow to dry and then darken one or two areas within the split, using the same colour. Repeat on the other side of the onion. Once dry, darken if necessary, as before.

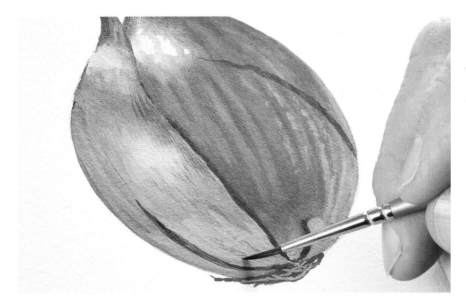

34 Make the colour more dilute by adding a small amount of water. Remove excess from your brush and with a damp (not wet) brush, add fine detail to the middle, the base and the top left, using delicate, thin strokes.

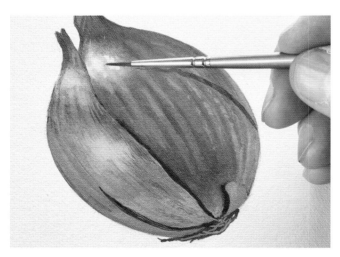

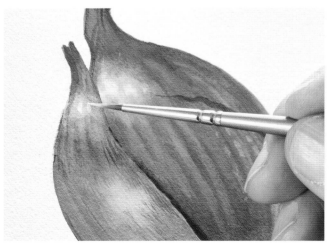

35 Soften any hard edges of the white patches with a clean, damp brush (size 0).

36 Increase the strength of the white in the upper left. As before, soften any unwanted hard edges.

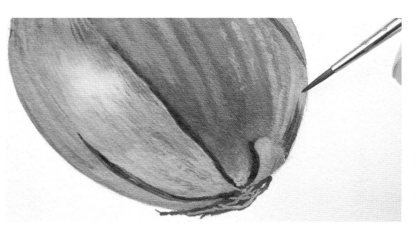

37 For the finishing touches, darken the lower right with permanent rose and a small amount of the aubergine mix, applying with a damp brush.

38 Add a tiny bit of zinc white to burnt sienna and highlight a few folds at the top of the onion.

39 Darken any shadow areas as necessary. I am darkening the shadow area under the skin on the left with aubergine mixed with Winsor green. Soften any unwanted hard edges as before.

You can see the finished painting on page 103.

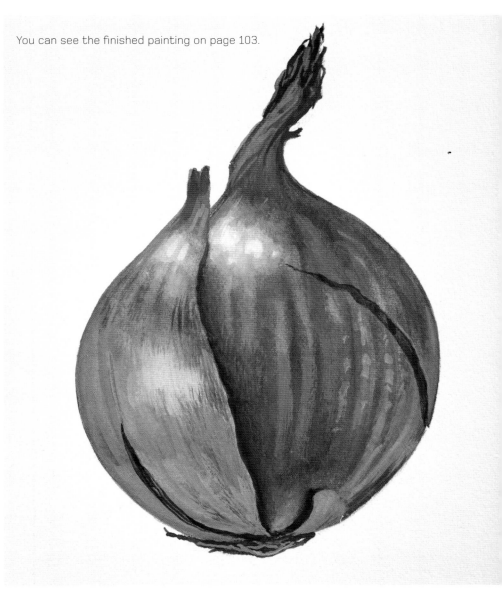

40 Allow to dry and then remove any extraneous pencil marks with an eraser. I am also sharpening up some of the edges, using a size 0 brush (and turning the painting upside down). Be careful you don't end up with a heavy outline around the edge.

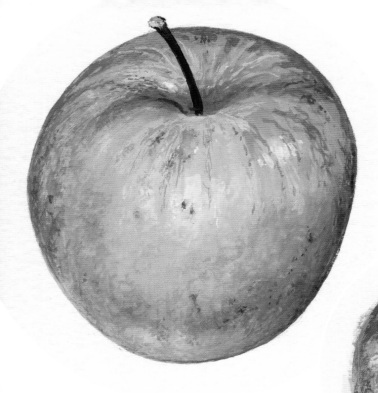

Apple

I positioned the apple in front of me at an angle so that I could look down on it slightly, as the indentation and the stalk are points of interest. Having drawn the shape, I started in a loose watercolour way within the drawing of the outline, with the basic colours and tones in their respective areas. After this had dried, the stronger, slightly thicker colours were added, gradually building up layers, using the brushstrokes directionally to create the shape and form of the apple. Finally, a small brush was used for detail and highlights such as the blemishes and the shine on the skin.

Another apple, painted in my own style which is 'looser' than the illustrative apple above.

Brown Onion

Fruit and vegetables are fantastic subjects for the illustrative style. This painting was started in a watercolour style, so paint was applied fairly thinly to begin with. Once dry, more paint was applied in slightly thicker layers. There are very subtle changes of colour and tone, and great care needs to be taken with good pointed brushes for adding the delicate detail.

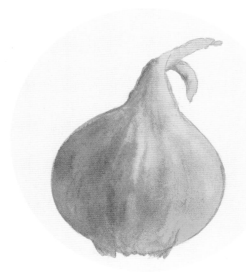

First stage of painting.

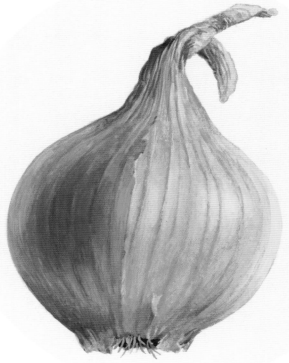

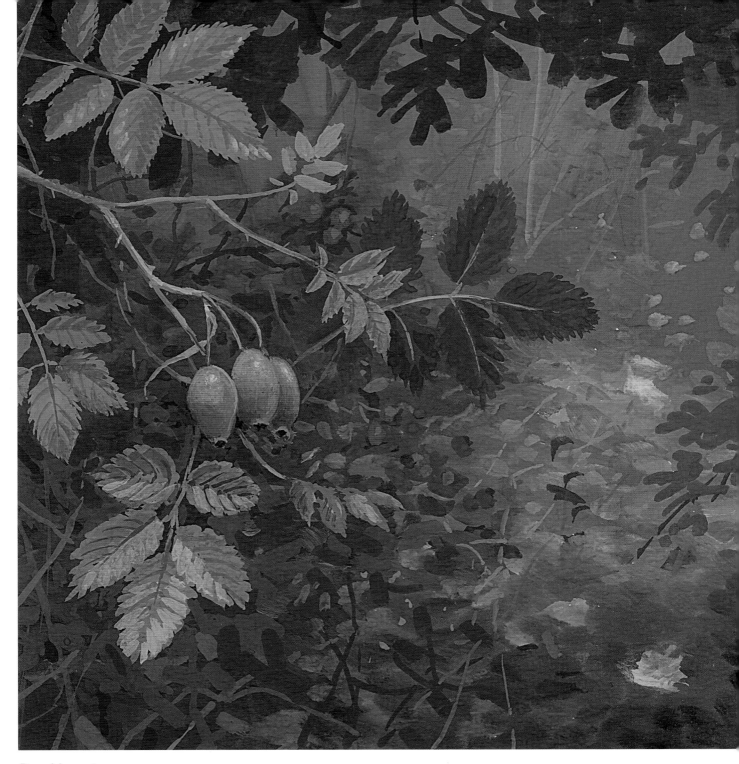

Rosehips, etc.

This was just a bit of experimental fun during a course I was teaching on gouache painting. While the main objects are illustrative in style, the background is slightly more loose.

Each object requires careful observation and the light, shade, texture and shine on the rosehip are characteristics that capture the illustrative nature of the subject. Initially, I just covered the background with a variety of mixed greens, then when dry I painted directly onto the paper without drawing with pencil first, because I knew I could paint over any mistakes if necessary. Working from the background to the foreground I overpainted each bit, waiting for each layer to dry. I matched the colours by testing them on a bit of paper and holding it in front of the objects, as I did with the ivy on page 100.

MOVING

FORWARDS

Snow Cyclist

Composition

What is it about a subject that makes you want to draw and paint it?

There may be many elements involved, such as colour, shape, atmosphere and any number of emotional factors. If you are working from photographs, don't necessarily copy everything in them, but consider whether you need all the visual information they provide. Would something be better omitted or added, or moved here or there?

You may hear people say not to put anything right in the middle of a painting, but if you like it in the middle, then why not? I might, however, avoid a composition that splits a painting in half from top to bottom in the middle of a picture, for example, a tree, unless it's for creating a particular effect such as a depiction of two worlds, two different seasons, or to show night and day.

I would try not to include too many main points of interest in a painting because the eye won't know what to focus on, or where to go. Ideally, the eye should be drawn in one direction and there may be one thing in particular that needs more attention, while less important aspects of the painting can lead the eye towards that. Many artists have agonized about composition over the centuries and countless theories abound.

I often play around with ideas, doing small thumbnail sketches or studies to work out an appealing composition, so do be prepared to experiment too. Many of my paintings that people see might not be the first version. I frequently paint the same or similar paintings over and over, until I settle on something I'm happy with. The ones that people don't see are seldom wasted, but instead have provided me with learning stepping stones to achieve the one that works in the end.

Oranges and Lemons

In this painting, I was particularly attracted to the bright colours of the fruit and the visual link of the yellow jug to the lemons. The blue earthenware bowl is a striking contrast to the complementary oranges, as well as a visual link to the pale blue striped cloth, and the dark blue-grey background. I played around with the composition, moving the objects here and there until I was happy that I had something that appealed to me. I like the looseness of this painting and I was happy to leave a lot of the original pencil work of the drawing.

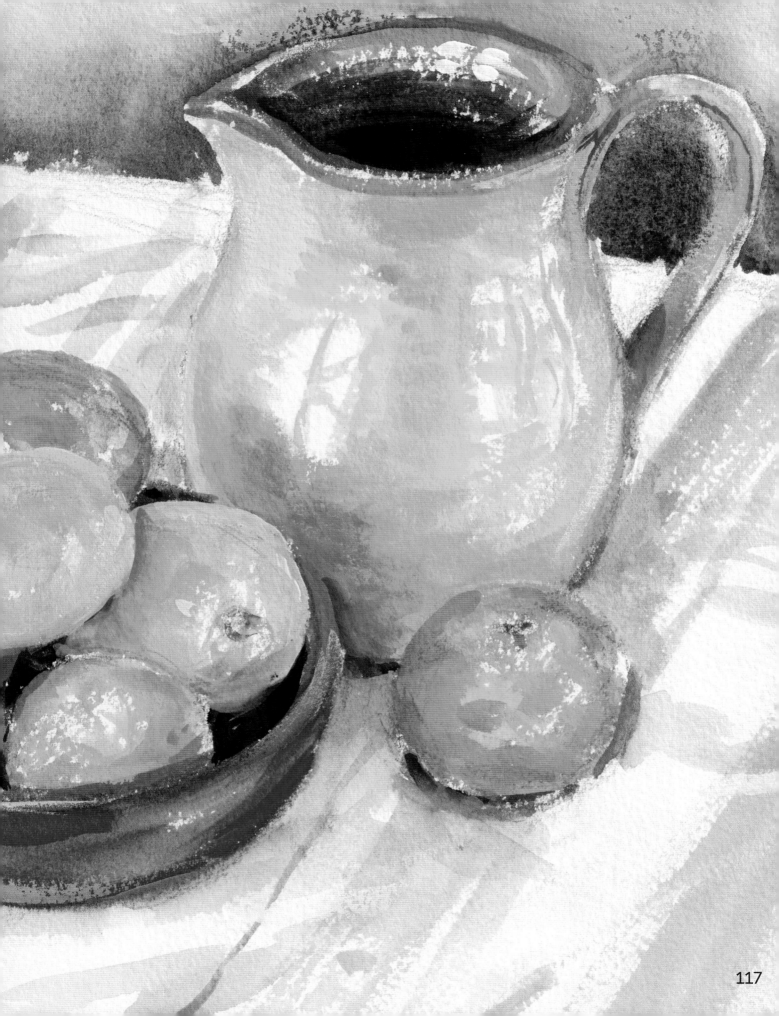

Perspective

Although this book is not primarily about perspective, it is important to understand perspective if we want to create accurate and realistic paintings. No amount of painting will cover up a misunderstood or bad perspective. Aerial perspective depicts spatial light, tone and colour. It creates a sense of distance as colours and tones fade further away. Linear perspective deals with where objects are in relation to each other. A subject's linear perspective needs careful consideration.

When we draw shapes that have parallel lines, such as buildings, we need to ensure that they look proportional, that they are correctly foreshortened, and that they recede towards a vanishing point correctly. Complicated angles can sometimes leave us perplexed as to how to draw them. Eye level is especially important for this, because that affects how objects look. As your eye level changes, so do the angles on objects and the vanishing points, and we need to pay particular attention to the direction of these angles. In many landscape scenes however, we may not need to worry about a vanishing point, as they probably won't contain any parallel lines. It's worth paying attention to eye level though:

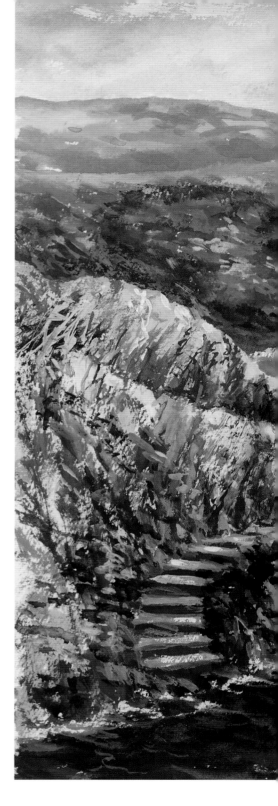

Low horizon

If our eye level is low, we see much more above the horizon. This kind of composition is ideal for a dramatic sky to create a feeling of immense space.

High horizon

If our eye level is high, the sky is less apparent and more land is visible. This perspective might be used where a lot of attention is wanted in the middle-distance and foreground.

118

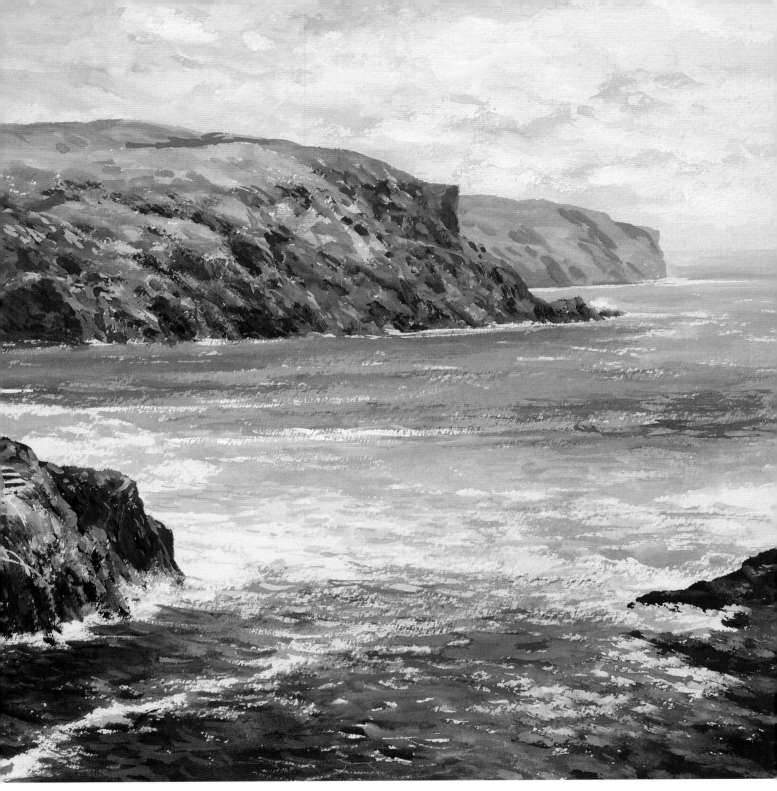

Spanish Head, Isle of Man

Here there is a fairly high horizon as I was looking down from the cliffs. We can see the effect of the aerial perspective in the colours further away, being more subdued tonally than the stronger colours in the foreground.

Key tip

I would try to avoid a 50:50 split of land and sky for a painting to be visually pleasing. One ought to be bigger than the other for a harmonious composition.

Drawing incidental figures

Small, incidental figures can add life to a landscape or town scene (see, for example, the cyclist on pages 114–115). It's always useful to find good reference that will help you understand how people move and stand, sit or lie, and sketching them is valuable experience. Try not to get too lost in detail, but initially look for basic shape, form and direction of a pose. Do it over and over again and, with practice, these studies will become better and better.

Proportions

Proportionately, there are about seven head-lengths to the average head-and-body length. Children's bodies are smaller, so their head takes up more of the overall head-and-body length than an adult's.

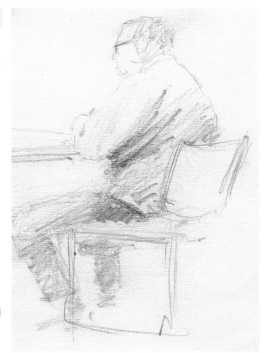

Photographs can be useful here, as they are an instant, helpful and contextually accurate guide. Context is important too, because if you use a reference photograph of a figure from one setting and paint it in another, a similar eye level, perspective and scale are essential for a convincing depiction.

Unless you're fairly confident I wouldn't attempt to paint figures without any reference, although distant, incidental figures might be more easily achievable. The lady sitting under the tree in *Cherry Blossom* on pages 6–7 is quite loose and impressionistic, easily painted (and corrected if need be) in gouache. Without her, the painting would be lacking a focal point, but she actually complements the cherry blossom as if she's part of a visual story.

The cyclist on pages 114–115 is also the focal point of that picture. Without him, the painting could look empty and lacking a visual story. I had a photograph as my reference for the cyclist, and the hardest things to paint were the circles of the wheels. Thankfully, with gouache you can keep adjusting until convincing circles eventually appear!

A good, simple shape to adopt for figures is a carrot shape, although be careful to make the top of the 'carrot' proportional to the body. Figures walking towards or away from the viewer can be drawn in this carrot-like way.

Try drawing a few figures like those below, over and over, then try painting them without drawing on a bit of spare paper or in a sketchbook.

Carrot-shaped figures

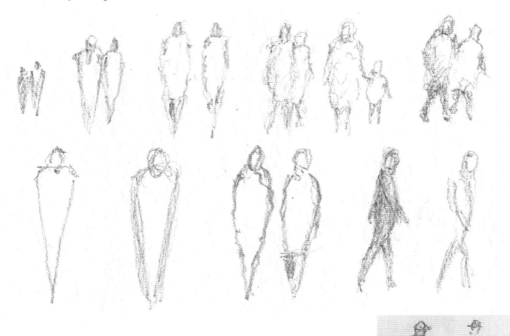

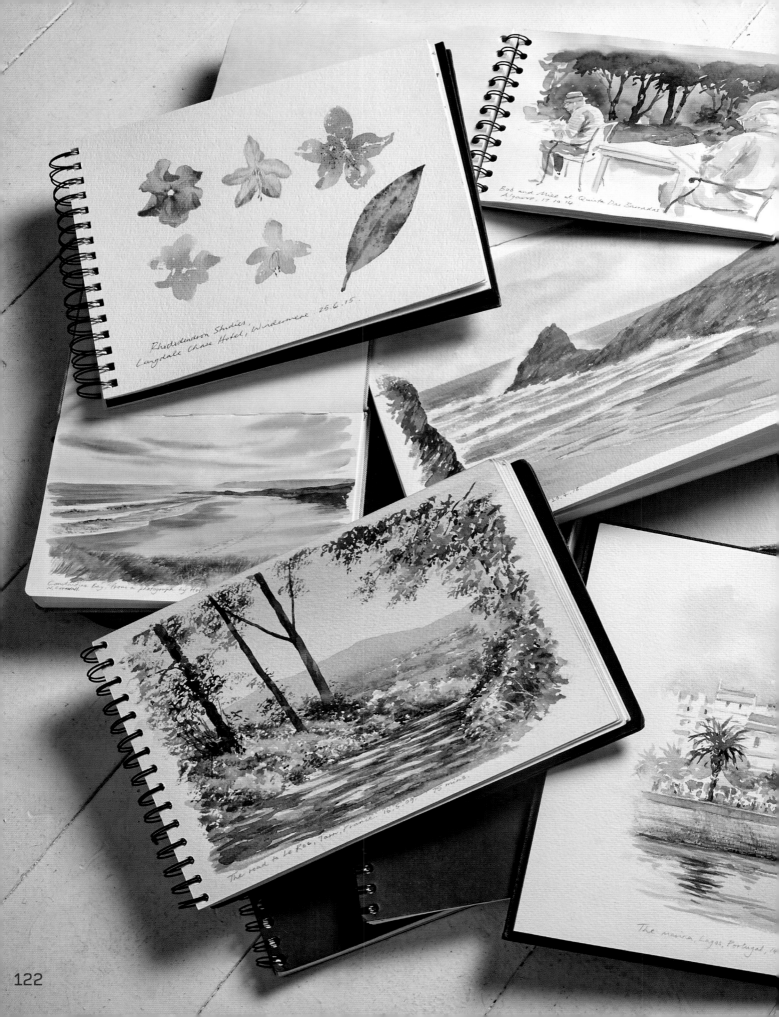

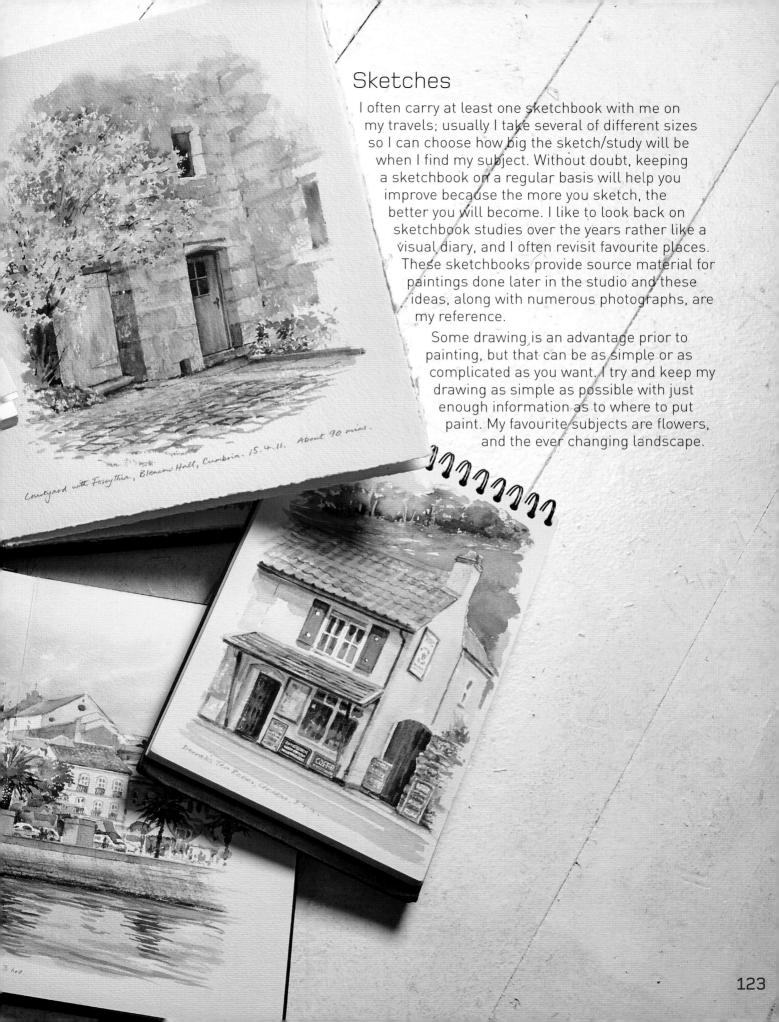

Sketches

I often carry at least one sketchbook with me on my travels; usually I take several of different sizes so I can choose how big the sketch/study will be when I find my subject. Without doubt, keeping a sketchbook on a regular basis will help you improve because the more you sketch, the better you will become. I like to look back on sketchbook studies over the years rather like a visual diary, and I often revisit favourite places. These sketchbooks provide source material for paintings done later in the studio and these ideas, along with numerous photographs, are my reference.

Some drawing is an advantage prior to painting, but that can be as simple or as complicated as you want. I try and keep my drawing as simple as possible with just enough information as to where to put paint. My favourite subjects are flowers, and the ever changing landscape.

Courtyard with Forsythia, Blencow Hall, Cumbria. 15.4.11. About 90 mins.

Using reference material

Good reference material is vital for me to be able to achieve a believable painting. If you have to make something up, it might work, but it could look unconvincing. Photographs are helpful, but I seldom rely on them one hundred per cent as the colours and tones can be exaggerated, so I only use them as a guide, or as the seed of an idea. I work from life wherever possible, often using sketchbooks which, along with photographs, can provide enough information for me to go back to the studio to work on paintings adapted from them.

The great joy of gouache is that when you start painting it doesn't have to be permanent, so you don't have to have a clear idea of the style you want to paint in. When I paint with gouache, I frequently start painting with only a rough idea of what I want to do and, as I progress, a style seems to emerge. If I don't like it I can go over it, again and again if necessary, and some different styles may well occur within the same painting.

My original sketch

I have no doubt that regular sketching greatly improves the artist. Sketches help us to work out compositions, colours, ideas, etc. and, whenever possible, I like to do them on location and as a reference for finished paintings to try and capture what I saw at that moment. If I have photographs as well, I can use the combination of both and adapt my finished work to suit. Colour and tone in photographs can be too strong, so my colour sketches will have a more accurate representation of the actual colours I saw.

My source photograph

The advantages of photographs are that they give you instant visual information if you don't have time to sketch. I rarely copy a photograph literally, but only use the information I want from it and adapt it to the way I want to paint.

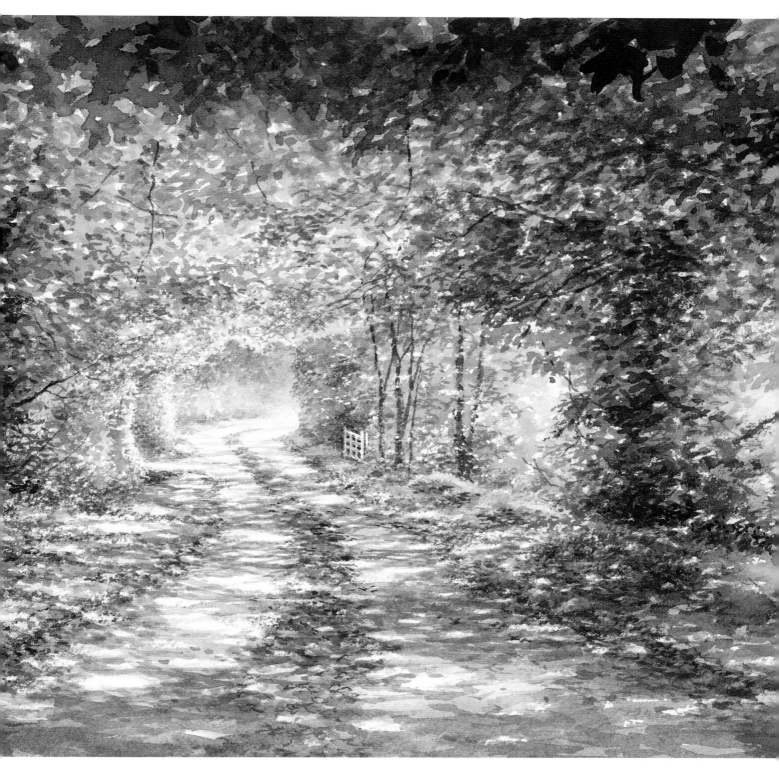

The Turning

Painting portraits

Painting people or animals is always challenging! However, gouache gives you the possibility of making a realistic finished portrait in an illustrative style. All the features have to be in the right places and being just fractionally out can completely alter the look of the subject. It takes a lot of concentration and attention to detail to capture a likeness. In the photograph of the man here, the right side is in shadow apart from the eye, but I thought to paint it that way might look a bit odd so I used dark flesh tones in that area instead.

If you can get a model to pose for you it is a valuable experience in observation, but not everyone is comfortable staying still for a lengthy time. A mirror image (self-portrait) can be worthwhile, although this is only how you see yourself and not how others see you.

Within the skin tones there are very subtle changes of colour and tone. Don't be anxious about painting chunks of colour without soft blending; you're just trying to capture an impression, and if skin is soft and smooth it doesn't have to be depicted that way. Remember that you are making artistic decisions and composing, not just copying.

Try not to paint a face that is evenly lit, but one that has some light and shade within it. Strong lights and darks can provide a really dramatic effect, as shown in the painting opposite. To begin, I look to accentuate the light by putting in the shadowy areas in a very loose way. I find it helpful to simplify shapes and establish their position with just a few marks or dots initially. As it comes together, the simplified areas are worked up gradually, without necessarily finishing one area before moving on to another. The danger of that approach is that you could paint a fantastic eye for example, but later find it's positioned wrongly and have to move it, thereby undoing all that hard work.

Source photograph of 'Barry'.

Opposite:
Barry
Portraits are traditionally realistic – here is an example. I think ideally, portraits want to say something of the look of the person and hopefully be recognizable by that person and by others, as that person.

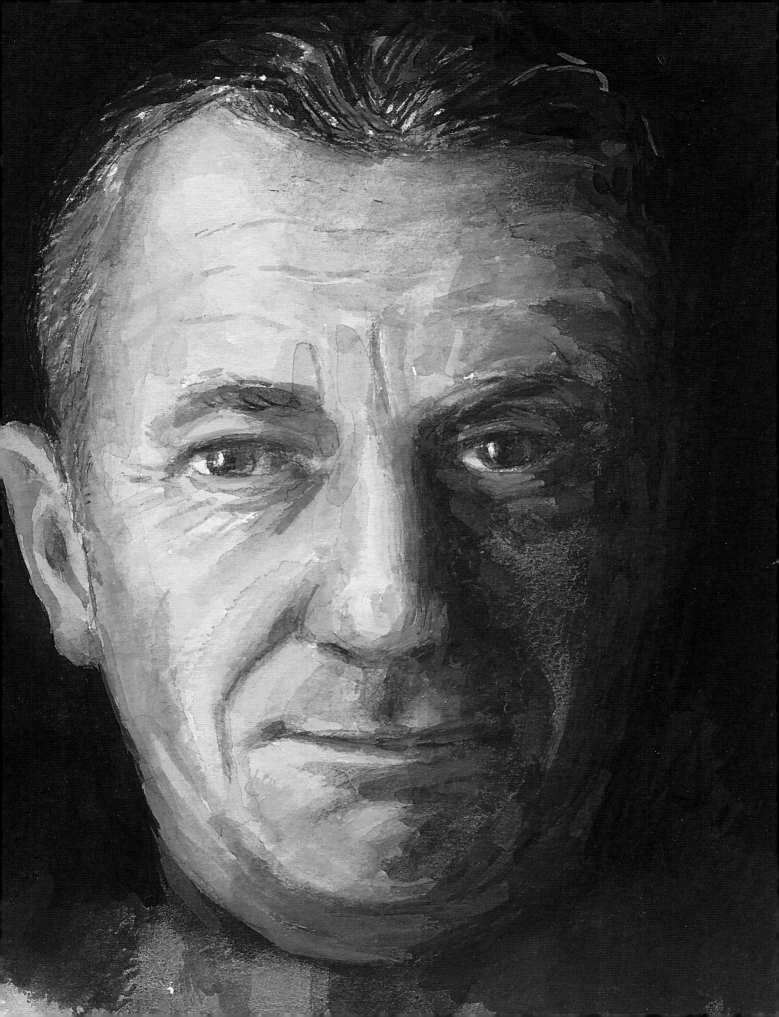

Stylized portraits

Portraits can be painted in any style, and poster-style portraits, although not easy, can be effective and striking, as you can see in the painting opposite. The main thing to bear in mind is simplification wherever possible, and in the poster style it can be difficult to isolate skin tones unless there is an obvious sharp contrast from one area of the face to another. I think this style is almost impossible to do from life as we don't see people that simply, so working from a good photographic image is essential.

Some smartphones and tablets allow you to play around with digital photographs. Computer programmes such as Photoshop give you the option of manipulating a subject and can do this for you. You can then use them as a reference for painting a simplified portrait from. This is particularly useful for working out areas of tone on faces. It may give you the option of various layers or levels of contrast depending upon how simple you want the image to be. For example, in the two posterized portraits of Barry here, the one at the top is much simpler, having only black and four other tones. In contrast, the one at the bottom is softer because there are more variations of tone. I created these posterized portraits in Photoshop by manipulating the original photograph and experimenting with the tools the programme provides. My painting of Barry on the opposite page is a bit of a compromise between the two, as I used some of the redder brown for the ear but I still wanted to keep the portrait simple.

To paint this accurately, you must draw carefully the edges of areas of tone with lines, rather like painting by numbers. If you want absolute accuracy, you can trace a printed copy of the manipulated image and transfer it onto your painting paper then fill in areas of tone with your mixed gouache colours, remembering to make plenty of each one in case you need to alter anything later on.

An advantage of this style of portraiture is that it appears quite dramatic because of its simplicity and starkness.

Digital photographs of Barry, manipulated in Photoshop.

Opposite:
Barry
Painted in poster style, this differs from the example on page 127, because there is no blending or subtle change of tones, only flat blocks or areas of tone and colour.

Capturing character

Source photograph of 'Kiera'.

Kiera, *my first portrait*

I often find it helpful to paint the same subject more than once to compare them. Using the source photograph to the left as a reference, I painted the portrait above onto smooth watercolour paper. However, when it was finished I realized that the angle of the head wasn't quite correct, as I have painted the face almost completely front on, whereas in the photograph Kiera has her head fractionally turned to her left. I decided to have another go at this portrait, this time on rough surface watercolour paper. You can see the result opposite.

Kiera, my second portrait

This is similar in style to *Barry* (see page 127), although I felt like using a rougher paper surface for a change. I used the same techniques and approach as the painting of Barry, although I decided to leave some of the background white. There was no reason for this, other than to show different settings and different methods for a portrait to stand out.

With a B pencil I drew in the key areas of the features of the face, indicating changes of light and dark with gentle pencil marks or slight shading. Having mixed a variety of skin colours, I started painting the face fairly watery to begin with, watching out for changes of light and tone. After that initial application of skin tones I started the eyes but didn't finish them, then I worked outwards a bit here and a bit there until it gradually began to take shape.

As the portrait progressed, I added more detail, although I tried not to get too fussy about some details such as the curls of Kiera's hair, as they are quite low down in the composition. Having done this shorter portrait, it would be good to compare another, longer portrait which includes the curls of the hair. In this case, I wanted to create an overall loosely painted impression rather than a photographic one.

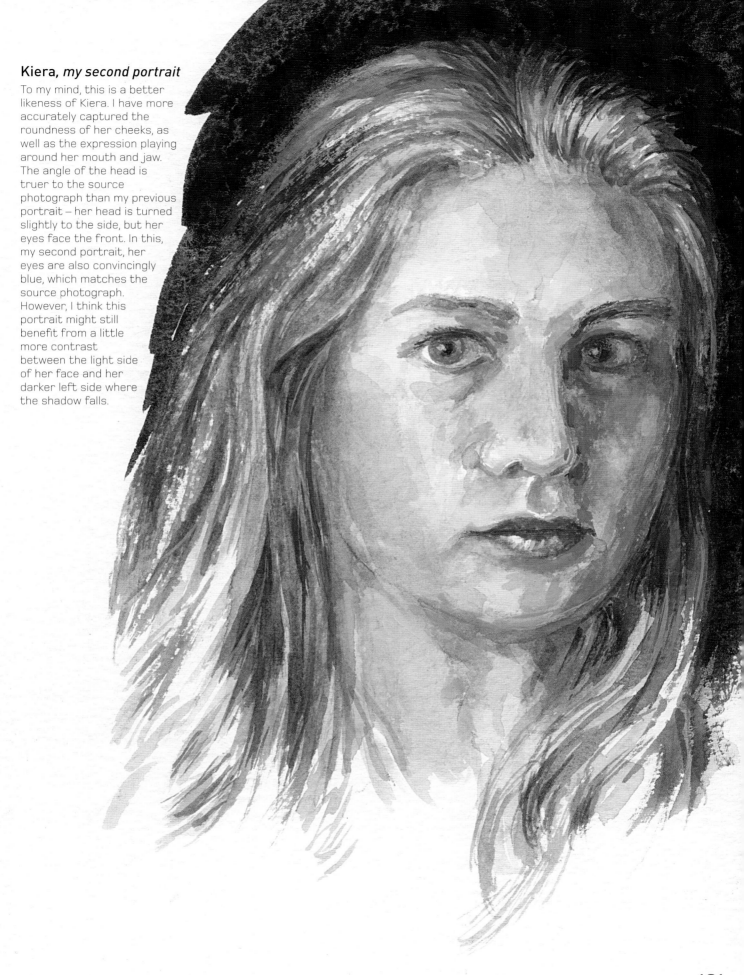

Kiera, *my second portrait*

To my mind, this is a better likeness of Kiera. I have more accurately captured the roundness of her cheeks, as well as the expression playing around her mouth and jaw. The angle of the head is truer to the source photograph than my previous portrait – her head is turned slightly to the side, but her eyes face the front. In this, my second portrait, her eyes are also convincingly blue, which matches the source photograph. However, I think this portrait might still benefit from a little more contrast between the light side of her face and her darker left side where the shadow falls.

Painting animals

I rarely paint animals from life unless they keep still for a long while, so using good photographic reference is essential. If you are taking photographs yourself, shoot from a variety of angles so you have as much information as possible and a number of different poses to choose from.

Painting *Our Dog, Jess*

As I describe on page 137, I started the painting below with a rough outline of the dog. Working outwards from the head, I painted the body loosely, then added more detail when dry. The grass and background were painted around the dog and I worked on both the background and the dog almost alternately, doing a bit on one, then a bit on the other. It's not essential to complete one area before working on another. It may be necessary to alter some areas every so often, and therefore I like to build it up gradually in all parts until it comes together as a whole painting.

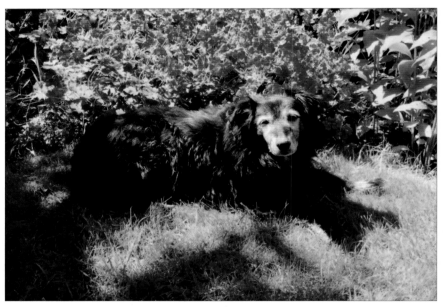

My original photograph.

Our Dog, Jess

This painting is a combination of different styles. I have painted my dog in a semi-illustrative style to make her look realistic, but I have also added my own unique gouache touch to it. For the background flowers I have combined the poster style and my own unique gouache style to give them a more loose and abstract feel, to ensure they don't draw the eye too much, as I want to keep the focus on the dog.

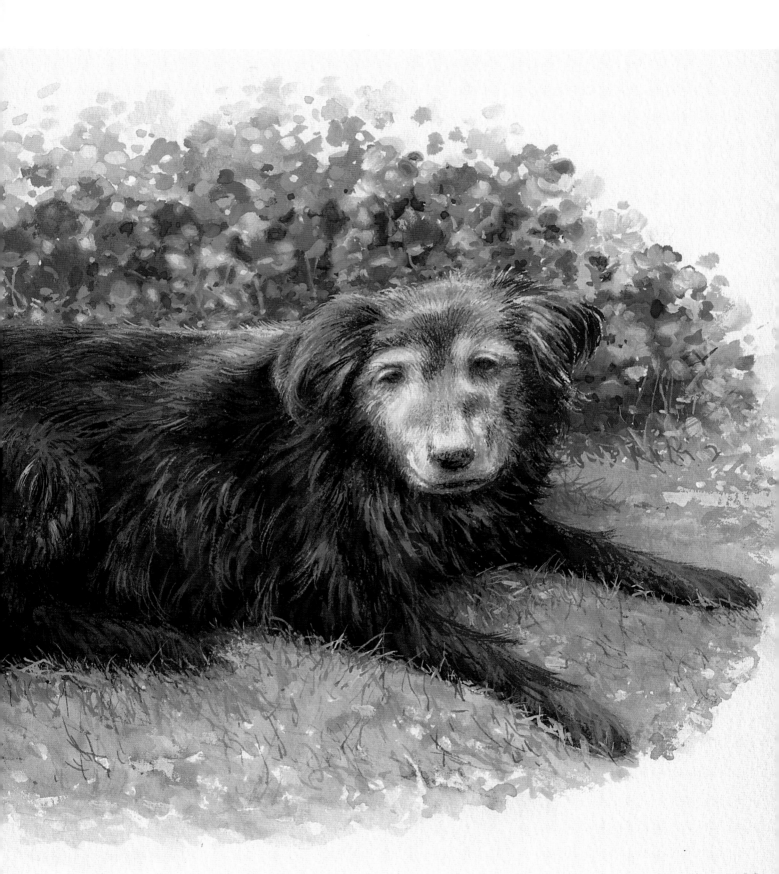

Painting fur

Before you begin to paint, look in detail at the subject. The light will reflect on different patches of the fur. Obviously, the colours you use need to match the colours of the animal subject. In this example, I'm only demonstrating the techniques, but these are applicable regardless of the colour of the fur.

Animals may not sit or stand still for very long so, unless you can work very quickly, I recommend working from photographs, and more than one if you can.

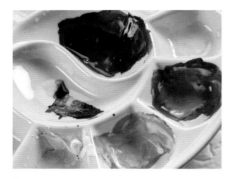

1 Mix jet black and zinc white (or any white) to make three mixes: pale grey, medium grey and dark grey. Also make some jet black of the same milky consistency as the greys. The colours you mix will, of course, depend upon the colour of the fur that you are painting.

2 Apply the paint in the direction that the fur is lying, using your black mix.

3 Then apply the dark grey mix, slightly overlapping the black.

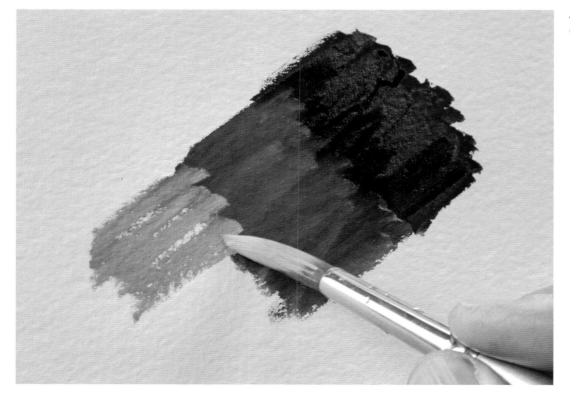

4 Do the same with the medium grey.

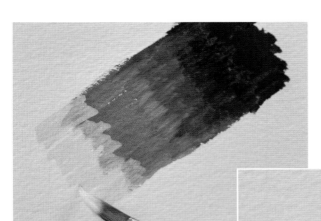

5 Repeat with the pale grey.

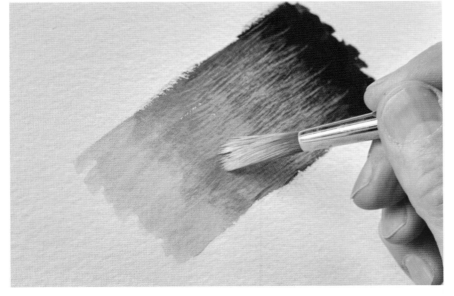

6 Almost dry your brush on kitchen paper and soften the edges where the tones meet, to blend the colours.

7 Put zinc white in a well where you can spread it out, with hardly any water, so the mixture is damp rather than wet. Remove any excess moisture on kitchen paper. Push the split brush back on itself in a clean area of the palette to pick up the paint. Drag it gently over the top of the first coat in the same direction, to create the effect of fur. See the section on splitting the brush on page 47.

Key tip

Using black on its own can be quite flat and uninteresting. Add a touch of ultramarine for a cooler black, or cadmium red for a warmer black.

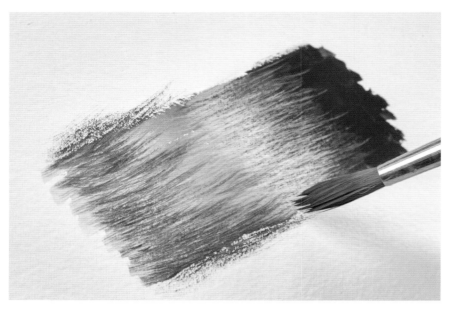

8 Dry your brush and repeat with the dark grey until you achieve the desired effect.

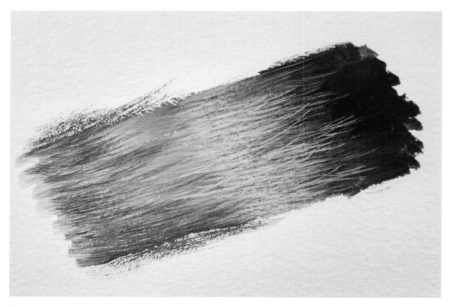

9 Finally, to highlight individual hairs, use a size 0 brush. As a general rule, the larger the area you are painting the larger the brush you will need.

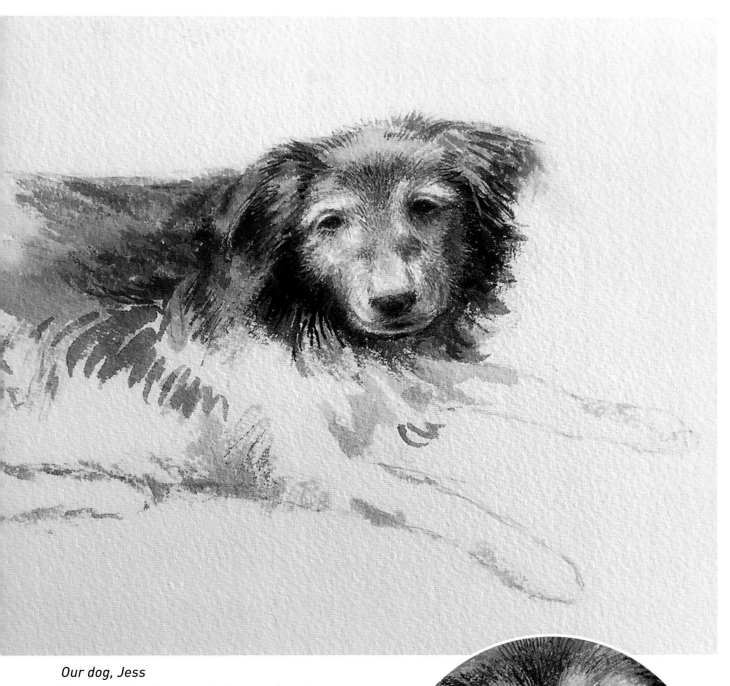

Our dog, Jess

You can see how I have used white gouache and various greys to give light and form to the fur. I drew a rough outline of the dog and started with a very small brush such as a size 0 or a size 1. Gradually working outwards from the eyes and head, the body was painted fairly wet and loosely then, when dry, more detail was added. You can see the finished painting on pages 132–133.

Painting *A Cat Called Ivy*

I painted this cat in the poster style and it works well, being simplified into shapes of tone and colour. I drew the basic shape of the animal, being very careful to get the eyes in exactly the right place because the eyes are all-important as they depict the character of the subject. If they are not exactly right, the portrait will not look precisely like the subject and the painting will not work properly. I painted black over most of the cat (except where the eyes are). I then went lighter and lighter with the greys, filling in with the eye colours then finishing with the background colours painted around the subject.

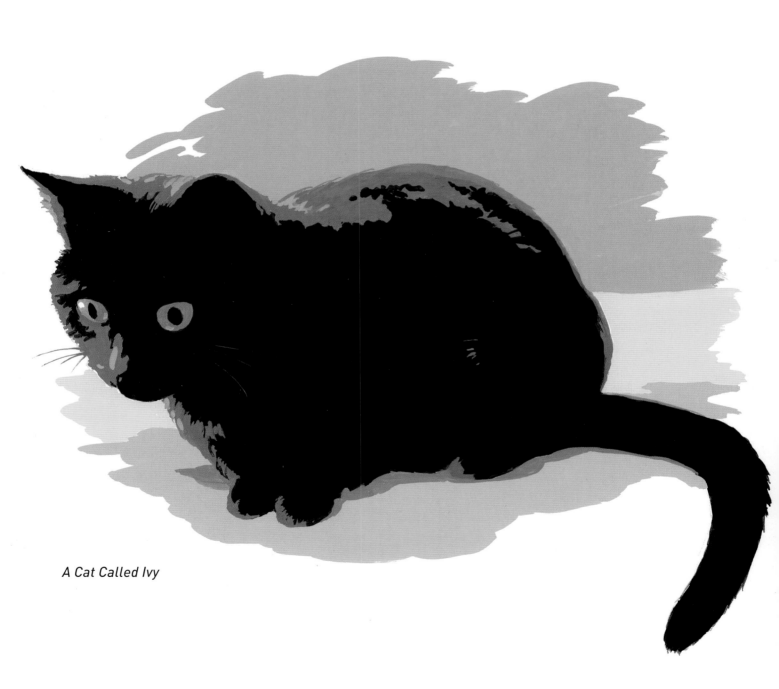

A Cat Called Ivy

Painting *Mia*

I painted this cat in an illustrative way, but the background and edges were done loosely in my own gouache watercolour style. I drew the head first, then painted the background around the head. When dry, I worked outwards from the eyes, gradually adding thicker and thicker gouache.

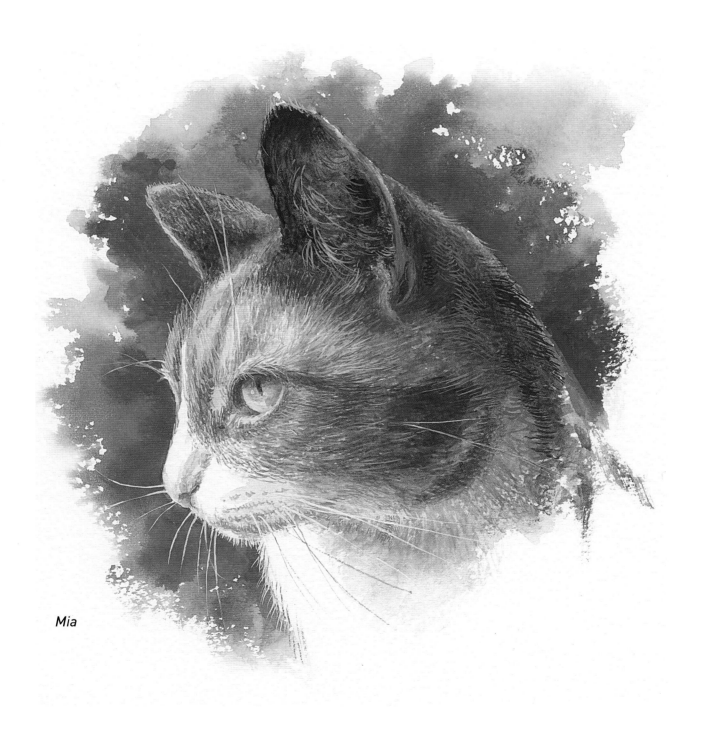

Mia

Framing and mounting

Paintings in gouache should not be varnished and should always be behind glass. I see a lot of paintings by a lot of people and I seldom think it's a good idea to put a painting in an old frame that's been sitting around in the garage or attic somewhere. A mount lifts an ordinary picture into the extraordinary, and a good frame projects it into the spectacular, so don't be tempted to scrimp or make do with a poor substitute if you want to show your hard-wrought creation in the best light.

When mounting paintings, I prefer either to have a single mount with a wash line, or a double mount. For most paintings I usually like a 7.5cm (3in) border all the way round, but this is a personal choice and others may think otherwise. If it's a double mount I may extend that to an overall 9cm (3.5in) with the inner mount providing the extra half an inch.

I like the mount and the frame to enhance the painting and not detract from it, so I usually choose simple and not too decorative frames that might have something of the colour of the painting in them. Mounts should complement the picture and not clash with it nor take attention away from the subject. Look for complete harmony throughout the presentation, giving your painting the best opportunity for admiration and success!

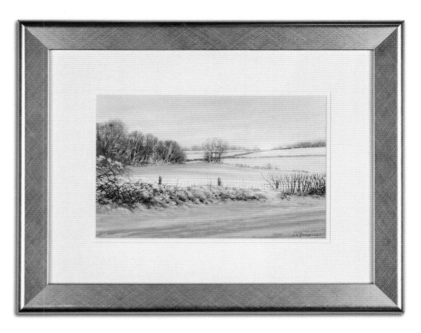

Last Light, East Hardwick

I chose a simple double mount and a silvery frame which I think goes well with the subject. You can see a larger version of this painting on pages 2–3.

The top of the picture was painted in a watercolour style then thicker paint was applied lower down towards the bottom. This way I could go over the dark foreground area in the hedge with the lighter snow colours.

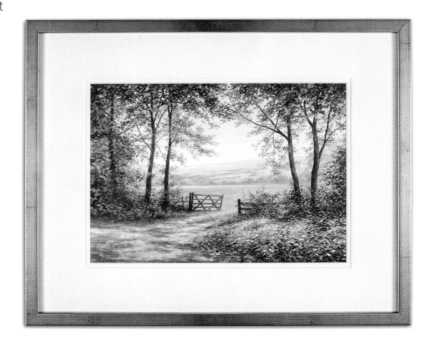

Near Dethick, Derbyshire

Again, this painting has a double mount and a subtle green frame to pick up some of the colour in the painting. You can see a larger version of this painting on pages 34–35.

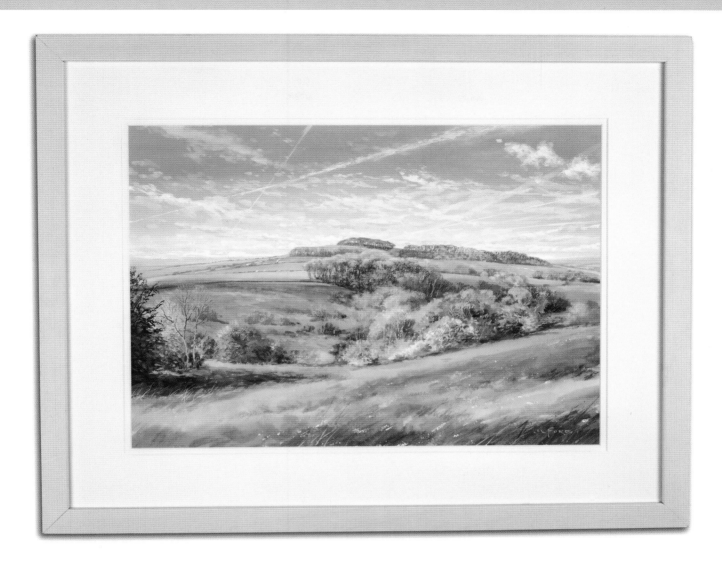

From Harper Hill

The double mount and plain light frame would go well on any wall and are in sharp contrast to the bright dramatic colours within the landscape, drawing attention to the subject.

All the colour mixes in this picture were milky and creamy in consistency. I started with the sky then overlaid the clouds and vapour trails once dry, working down from the background into the foreground, overlaying colours where necessary.

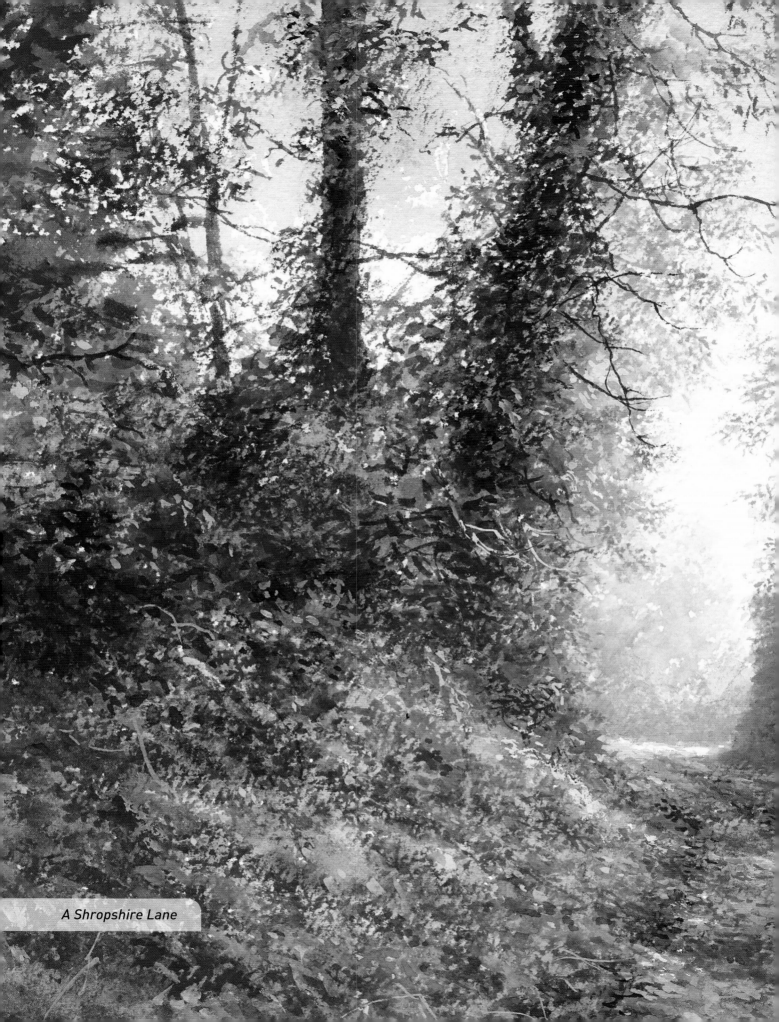

A Shropshire Lane

Afterword

There is a saying: 'If it was easy, everyone would be doing it!'

In my opinion, painting is seldom easy but it is tremendous fun as you become absolutely engrossed in your subject matter, trying to capture something of the essence of what it is that attracted you to it. Painting in any medium is also frustrating as we make mistakes, but these mistakes are how we learn and we must use these experiences positively if we are not to be discouraged. When a painting works it is a great feeling, but sometimes the next painting may bring you back down to earth!

I urge you to persevere through any difficulties you may encounter and through repetition and practice we improve over time. Gouache, of all the paint media, is I believe the one best able to provide pleasing results in so many varying styles, and I hope you enjoy painting your own creations, as I have, with this wonderful, exciting medium. Happy painting!

Index